moon goddess

FOR RON

Our
natural satelite that
shines by the sun's reflec-
tive light, revolves about the
earth from west to east every 29.5
days with reference to the sun, and
has a diameter of 3475 kilometers, a
mean distance from the earth of about
384,000 kilometers and a mass about one
eightieth that of the earth. The moon is in
sychronous rotation with earth, always
showing the same face with it's near
side marked by dark volcanic maria
that fills between the bright
anciet crustal highlands and
the impact crators.

She is Moon Goddess, Bright Mother, bringer of stability and sinuous, flowing changes. She watches, fascinated, by the frenetic tide of humans feasting, gnawing, and worshipping the earth, like children. Her nature ebbs and flows like passion, like inspiration. We worship her cool, indifferent light, the respite she offers from glaring solar rays; searching for meaning. She is mystery, though she is known. She is a whole unto herself, but she is merely a reflection. Worlds live, die, and collide, but she remains.

CONTENTS

DRE FREDEN — 1

JORDAN GREEN — 5

BRIAN HERITAGE — 9

JENESSA LINGARD — 13

ANN MIDDLETON	17
ANDREW MITCHELL	21
EMILY MITCHELL	25
RACHEL ROSS	29
RYLIE SAVAGE	33
JOHN TAYLOR	37

DRE

When the project was given the name, "Moon Goddess," I tried to think of a story to go along with the name. I had to decide which people's lore she would fit into and how they would have seen her through their eyes. I figured it would be an ancient race, since, Romans, Greeks and Egyptians all had gods and goddesses based around celestial bodies and man's core instinctual drives. On the same hand, I didn't want it to be a literal translation, as they are all well known from history books and felt it would be less creative. I decided to take it in a more supernatural direction.

On the full moon, the dead would arise and monsters would lurk in the darkness. Too many friends and family had been lost, so the Mayans called upon their high priest to implore the sun god for help. Through a vision, the priest was given guidance on how to build ships that could fly a group of their finest warriors to face down the goddess on the moon. If they could seal her in her own dungeons, her powers wouldn't be able to reach the earth for two thousand years.

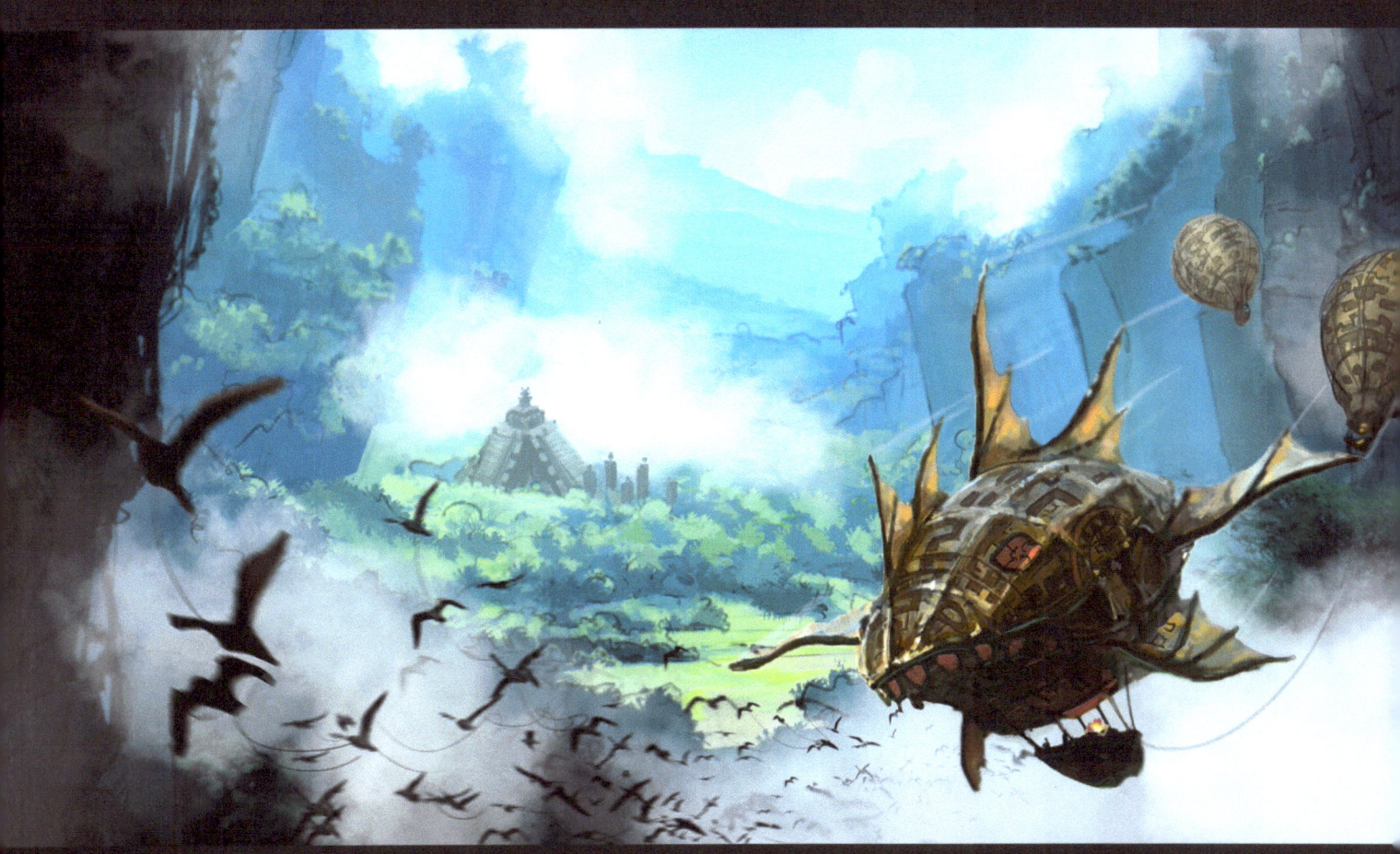

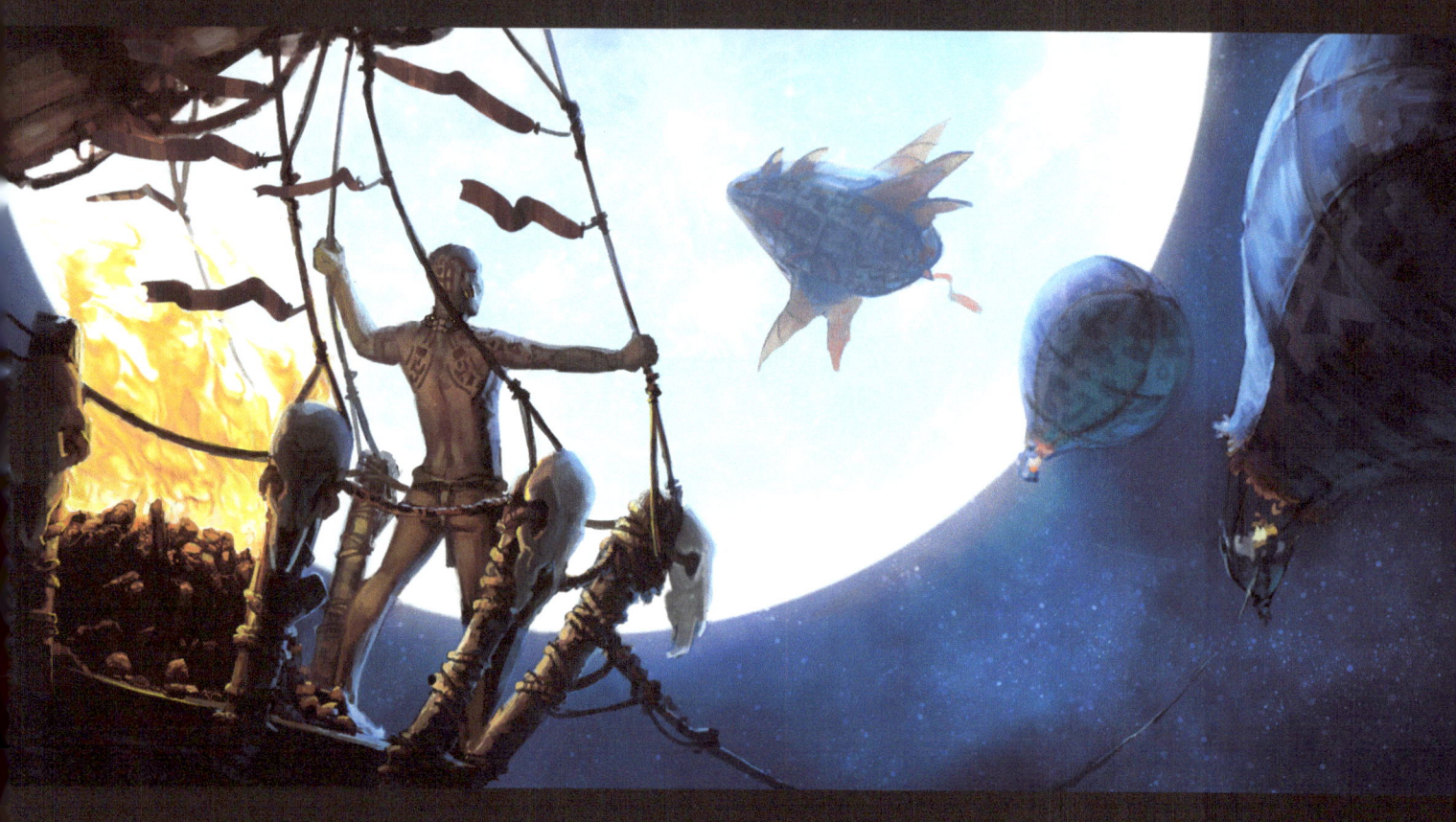

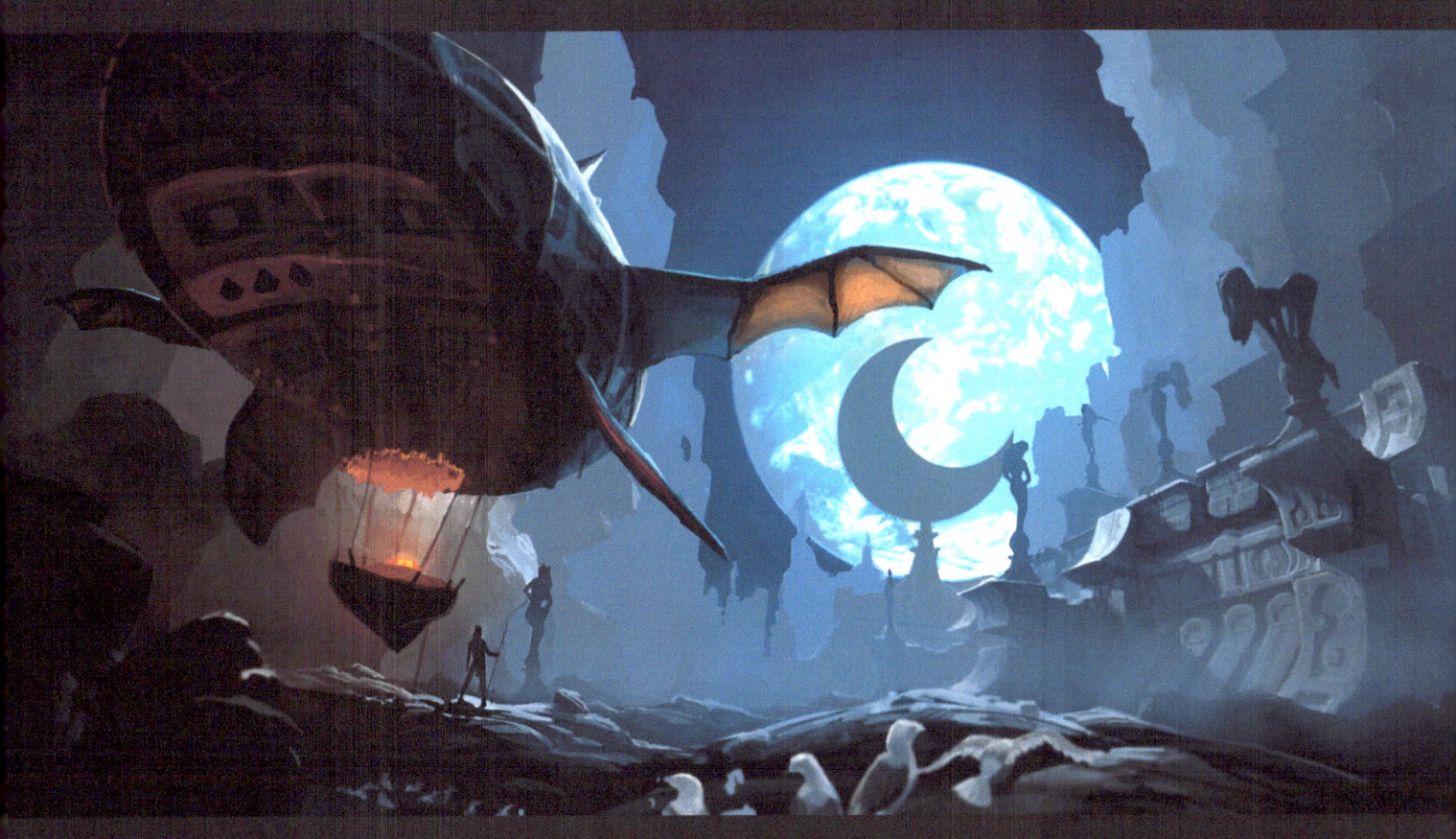

JORDAN

The moon is a symbol of creation and creativity. In legends and myth the moon is often portrayed as feminine and, for me, a close corollary with femininity is protection. These ideas caused me to envision a heroine that could be the literal protector of earth. My ideas for this project quickly gravitated towards visual representations of a physical (and spiritual) struggle against a strange and powerful enemy. The first moon goddess piece represents the engagement with the adversary and the need to make a strategic retreat as the enemy proves to be more powerful than anticipated. The second painting depicts the moon goddess destroying the main adversary or "big boss." I didn't intend for the him to look like a dragon but people have interpreted that way, which ok, though the idea for the second painting's monster was inspired by one of the tiles on my bathroom floor, you never know what you'll see in organic random patterns. The third piece represents the moon goddess's triumph and then return to the moon, her home, until she is needed to come help defend the human race again.

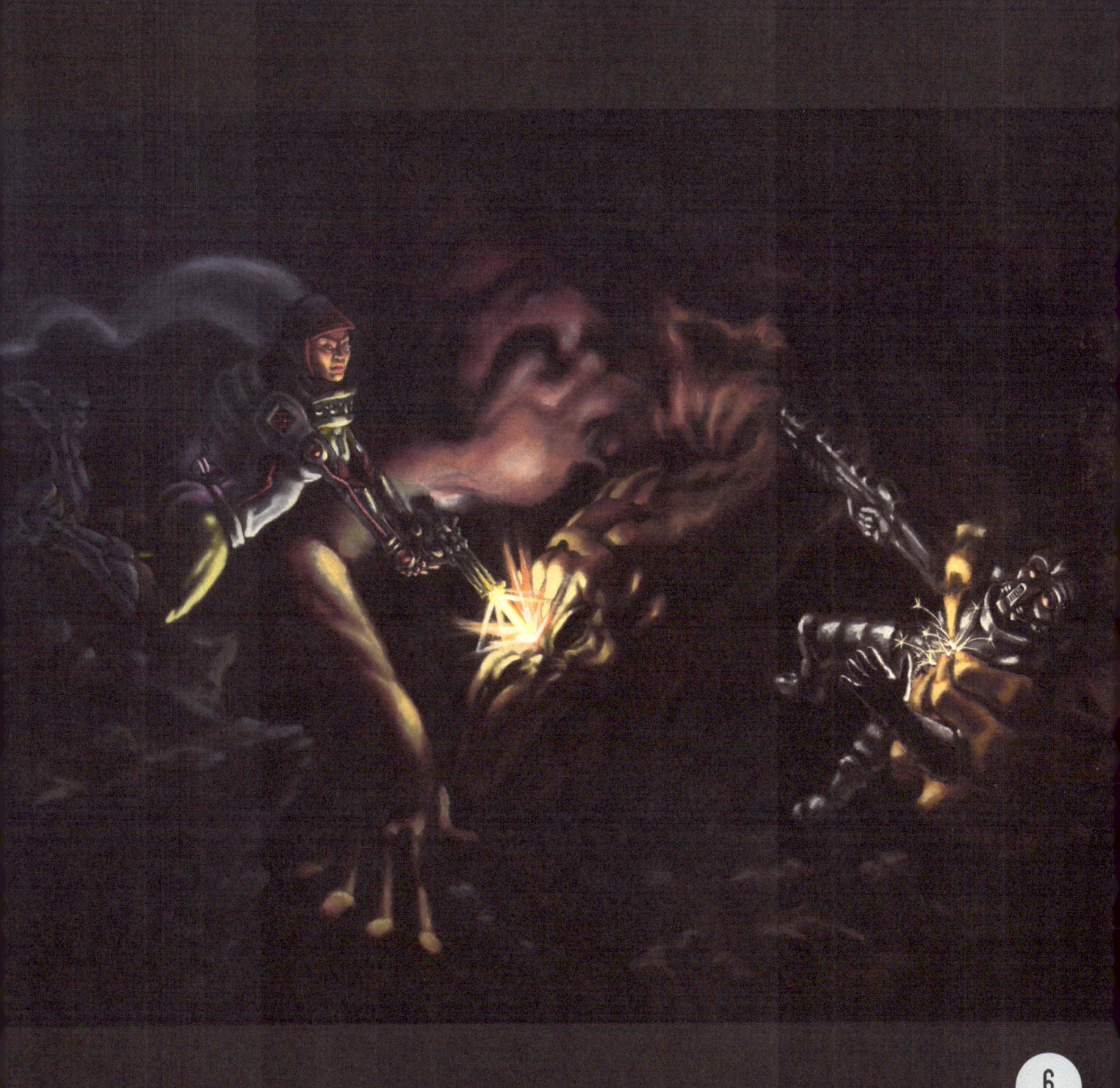

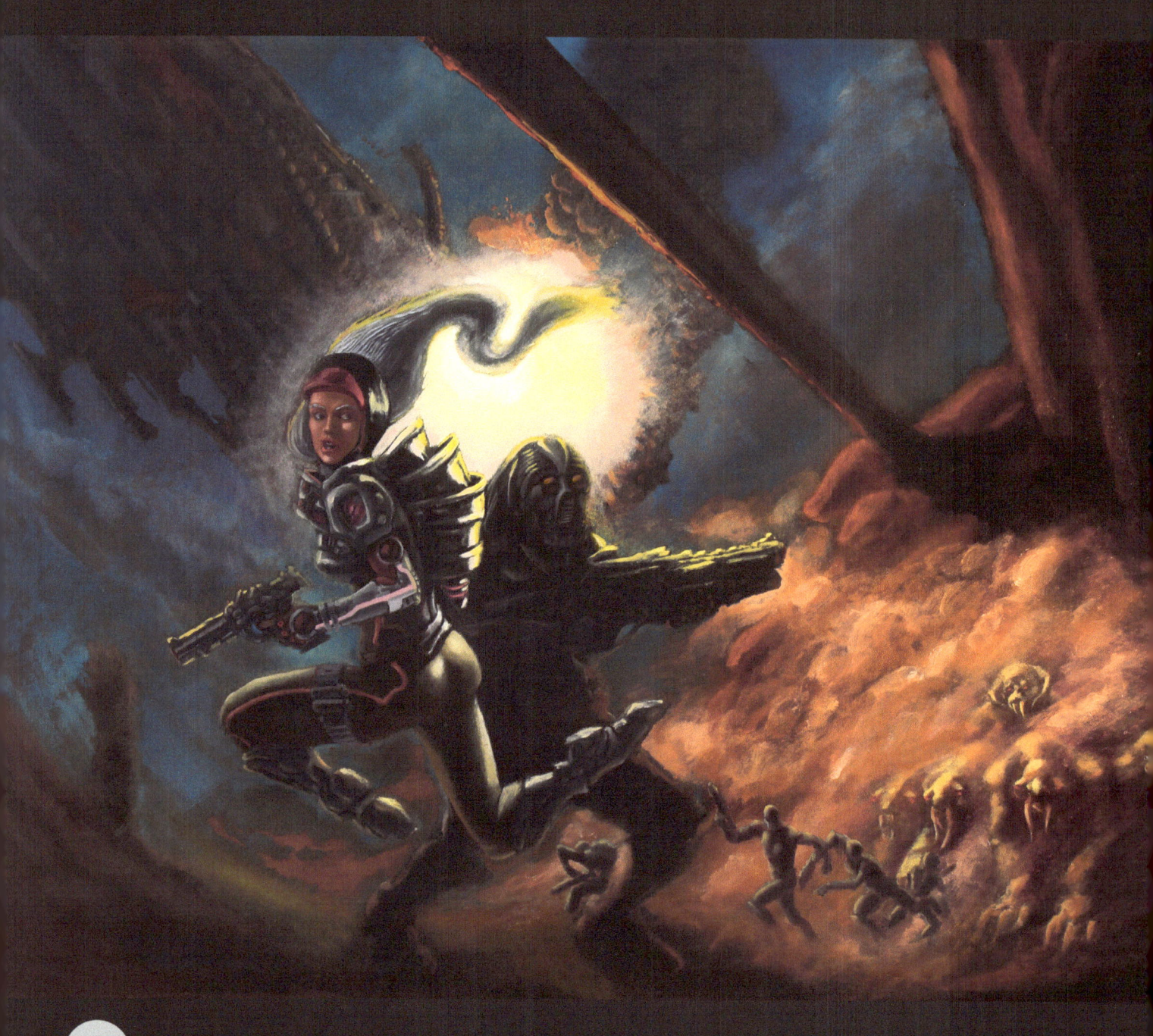

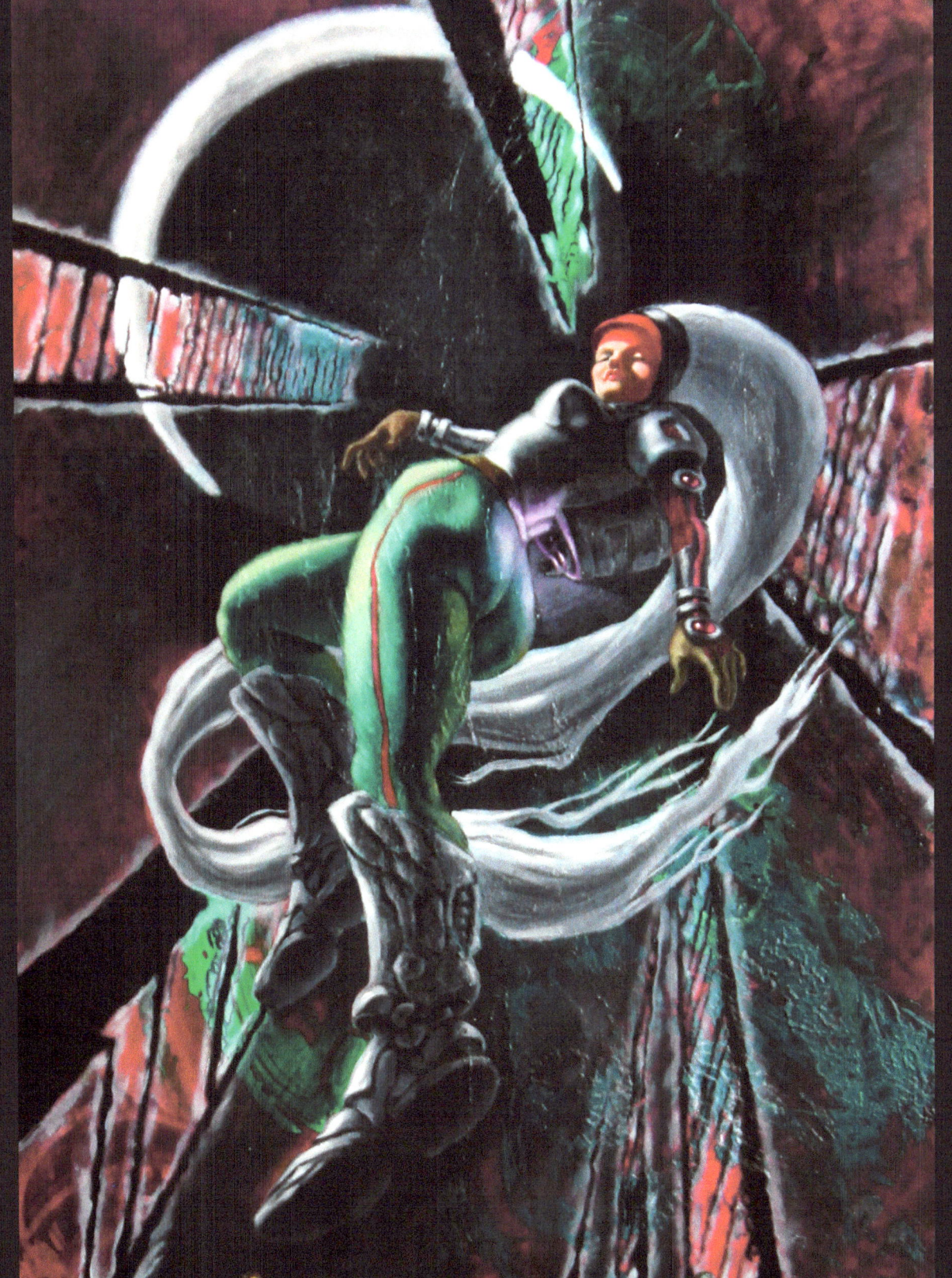

BRIAN

Many cultures and myths associate the moon with the afterlife. In this story the moon goddess acts a Charon, the ferryman, by leading the spirits of the dead toward their final resting place. They must follow her path through the sky, beyond the horizon into the underworld. But, guiding the worthy to rest isn't her only function. She is an instrument of justice by omission. If the spirits aren't worthy of rest, she may not come to show them the way. She may dim her light so only the most determined could follow her. She is both cruel in her abandonment and saintly in her guidance.

For this series of illustrations, I wanted to immerse the viewer in a compelling narrative. So, I made the viewer one of these newly disembodied spirits, The point of view for each piece changes in relation to were the spirit is on it's journey. My hope is that, by seeing these images, the viewer might get a small taste of the awe and excitement that would accompany that journey.

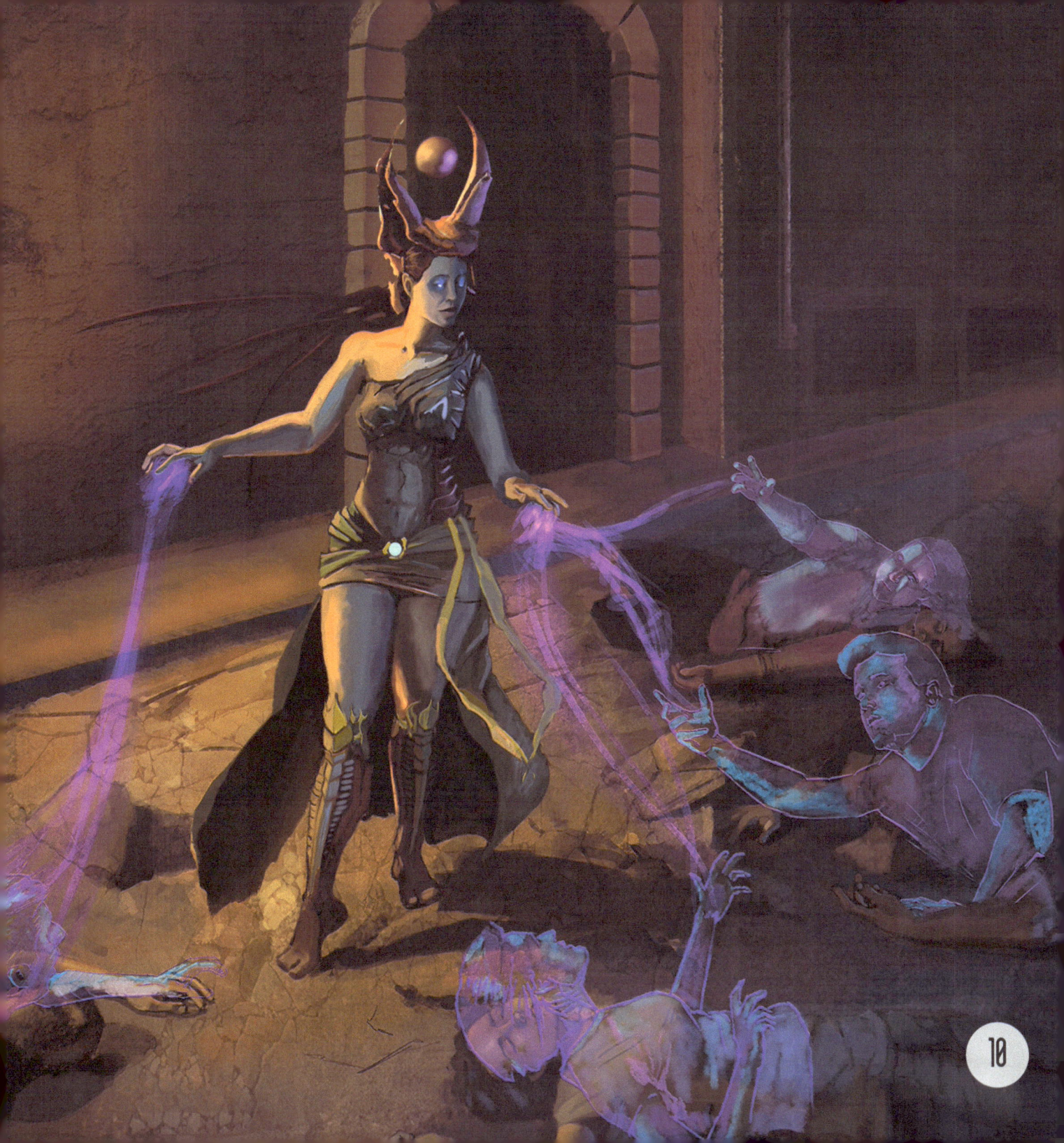

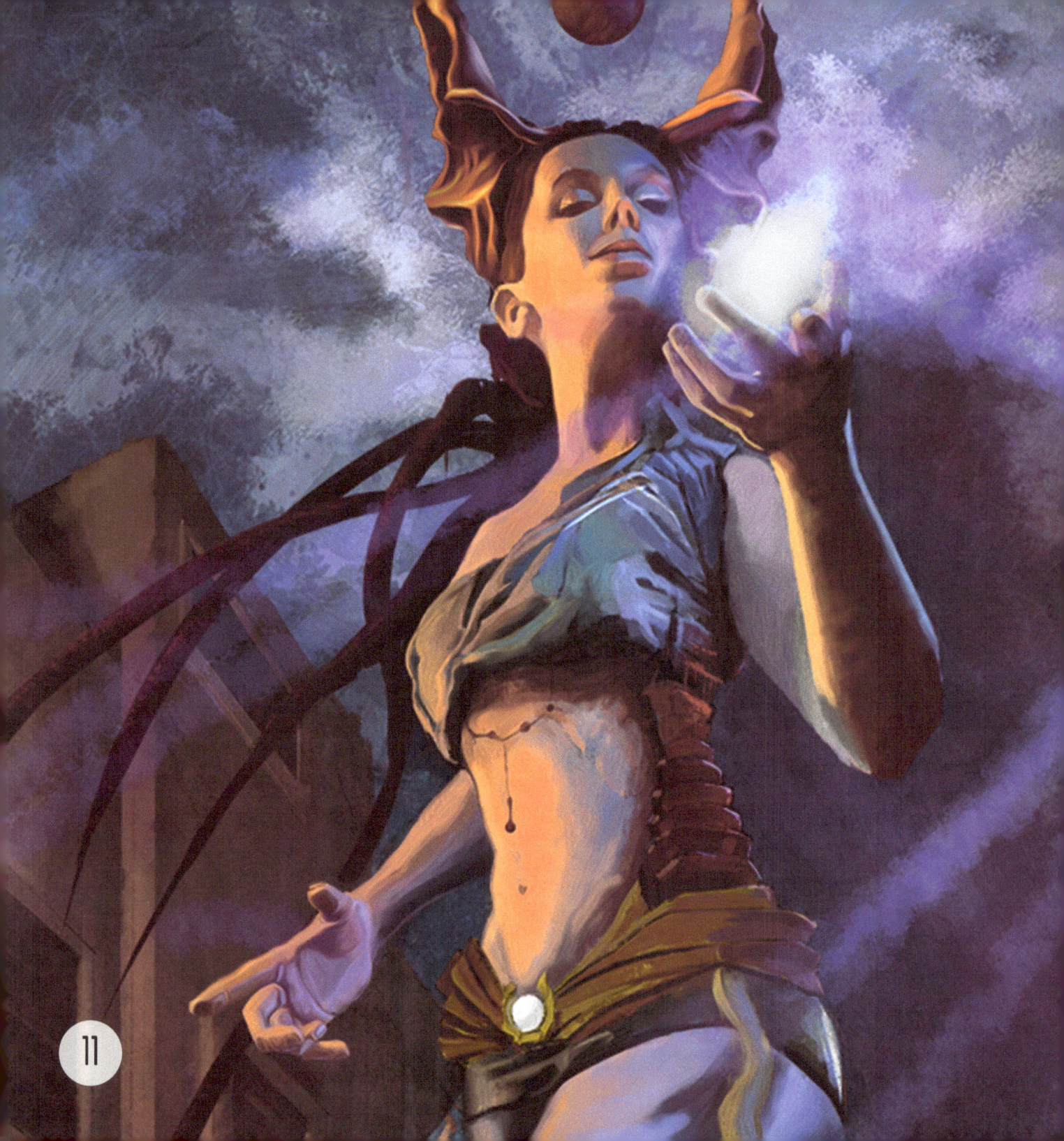

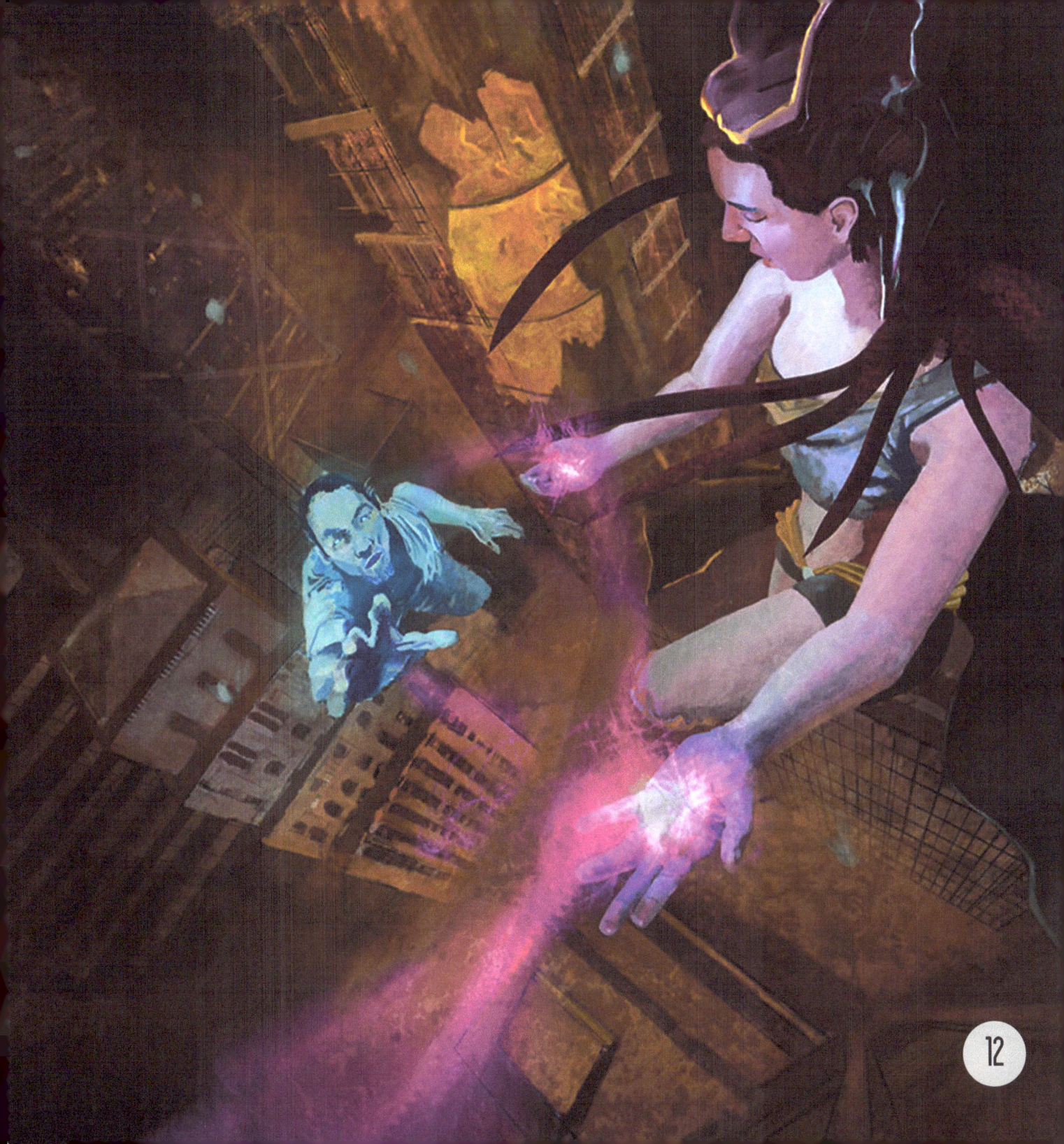

JENESSA

I wanted to evoke a feeling reminiscent of Art Nouveau for the three pieces I created for this project. Each image reflects a different Moon Goddess in that stage of the moon cycle. The waning moon shows a slender and lofty girl draped across the crescent shape in a melancholy fashion as she slowly diminishes into the night sky. The eclipsed moon goddess is huddled in a ball as she blocks out the sun demonstrating the feeling of uncertainty as her actions affect things beyond her control. Her pose represents, to me, the contemplation that should follow such vast proceedings.

The full moon represents the feeling of being free and uninhibited; she stretches as her radiance spreads out across the countryside and travels across the earth exploring all that she can during her nighttime stroll. I chose to illustrate this goddess as a mature young woman because the time period of the moon being truly full is fleeting. During this stage she finds herself neither growing nor wasting away for a free and youthful night.

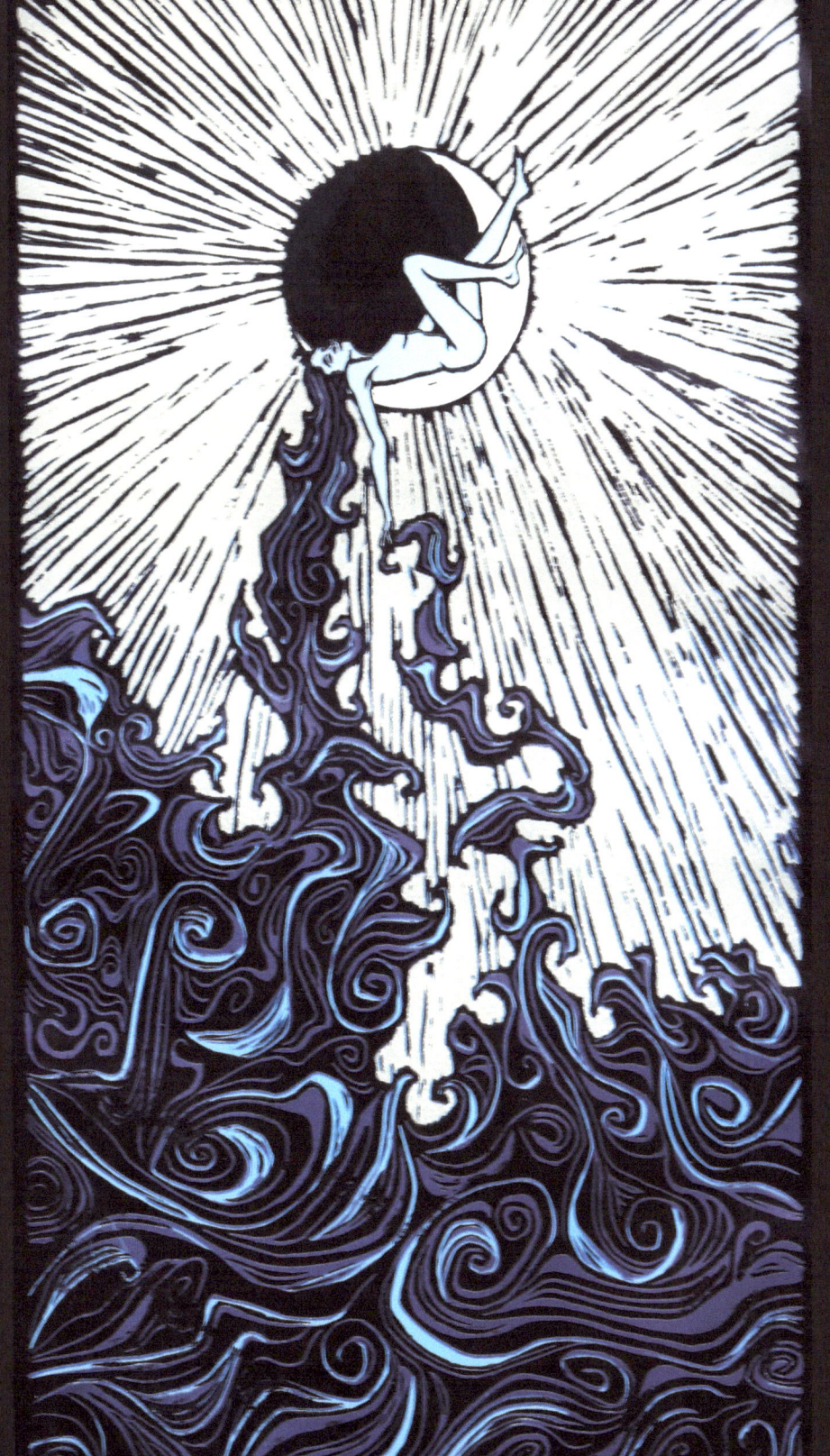

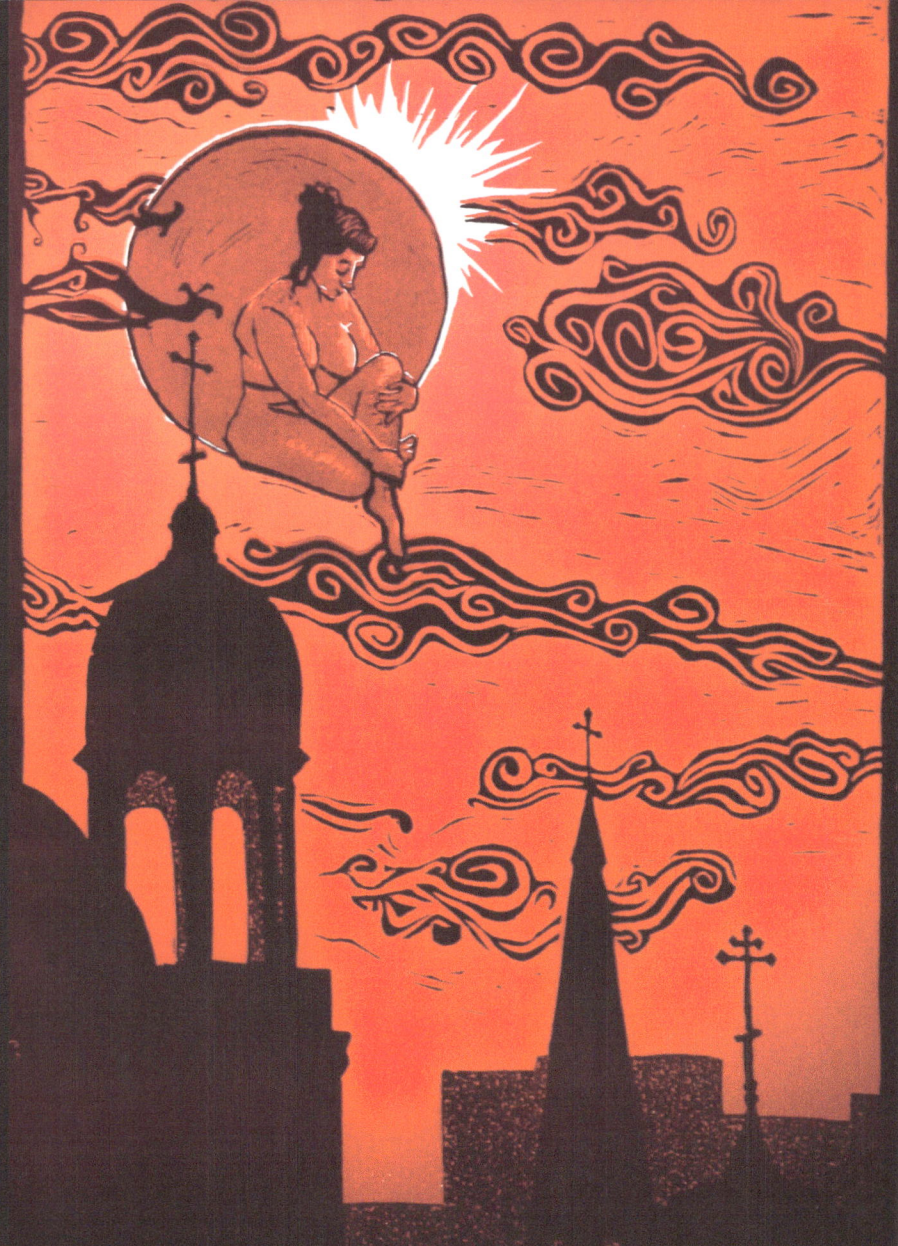

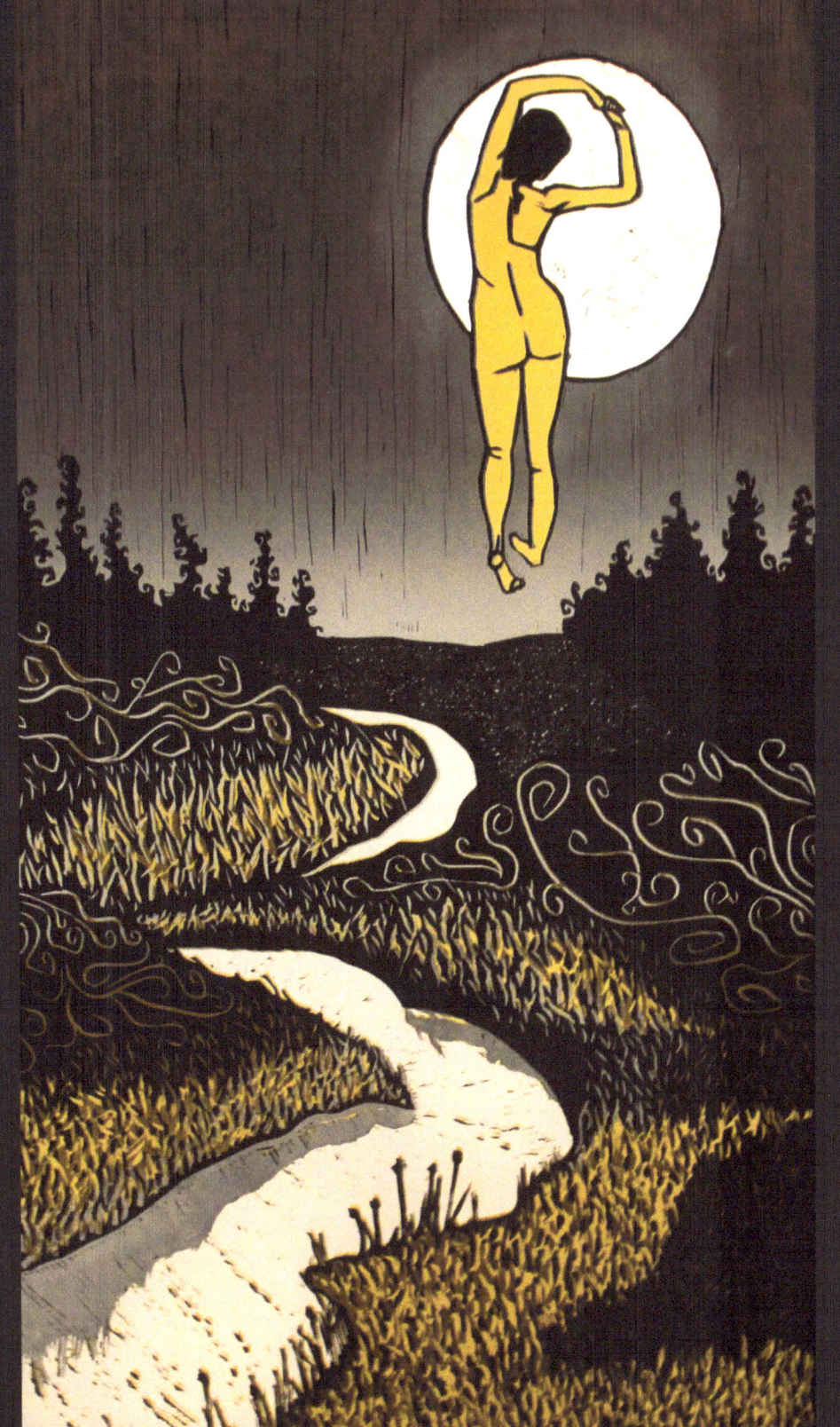

ANN

One sister feuds with the other over dominance of the moon. The light and the dark gaining and losing ground as the days and months go on...

After much trial and error, I ended up on a very focused and formal idea involving mainly the Dark side of the moon and her minions. Mainly going off the premise that this feud between the dark and the light sides of the moon could have been continuing on for thousands of years. Perhaps these moon sisters feud over who gets which half of the room! Neither being good nor evil, just opposites.

With the basic concept in mind, I drew on my travels visiting family in Thailand to create the "Hanuman" warriors and the motifs around each piece. This gave me a way to keep mental track of my progress and keep cohesion in composition and patterning. Cohesion was a big factor for me. It was the patterns that really became one of the more important elements of the pieces. Tangles, curves, and traditional imagery helped keep the concept intact.

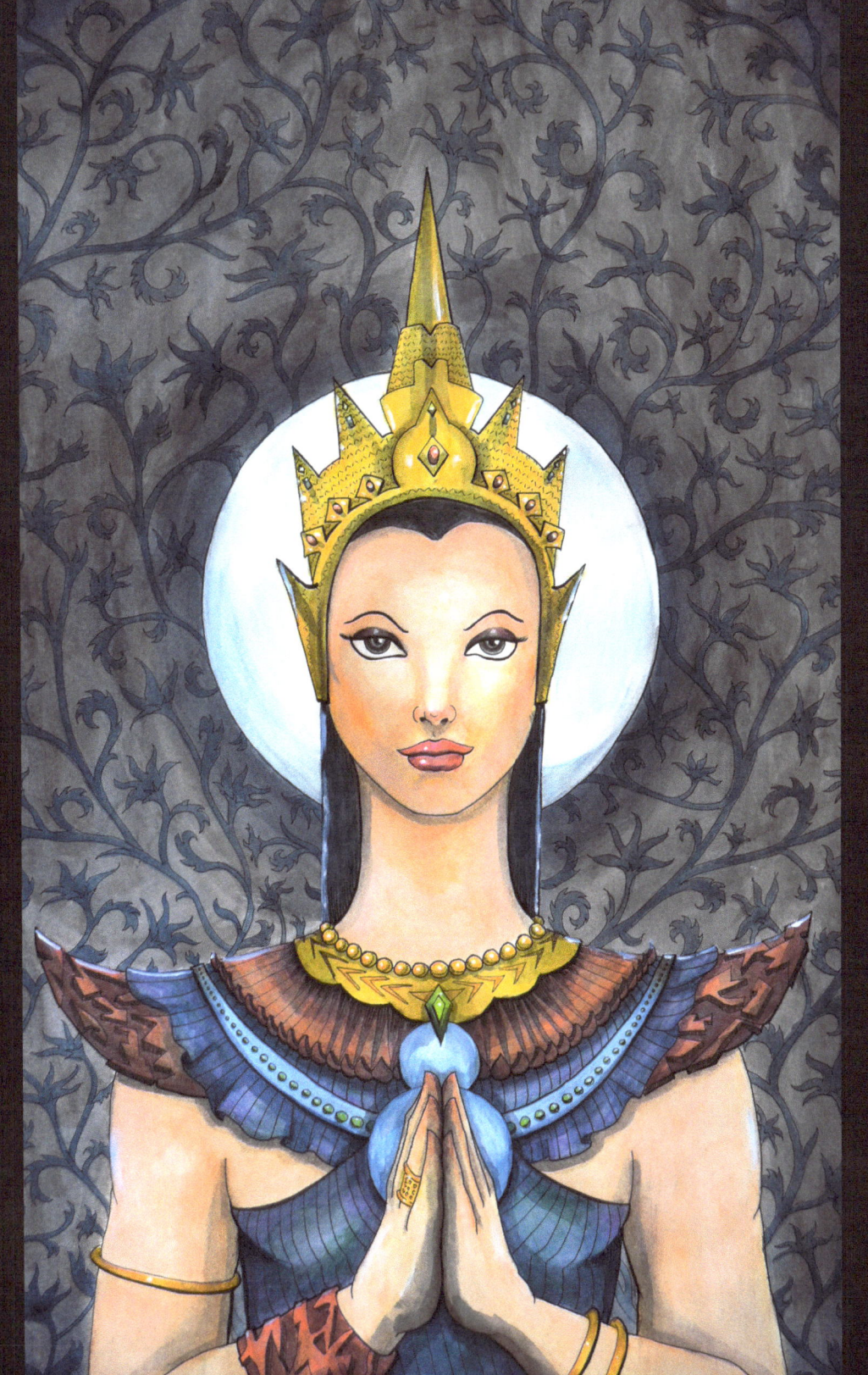

19

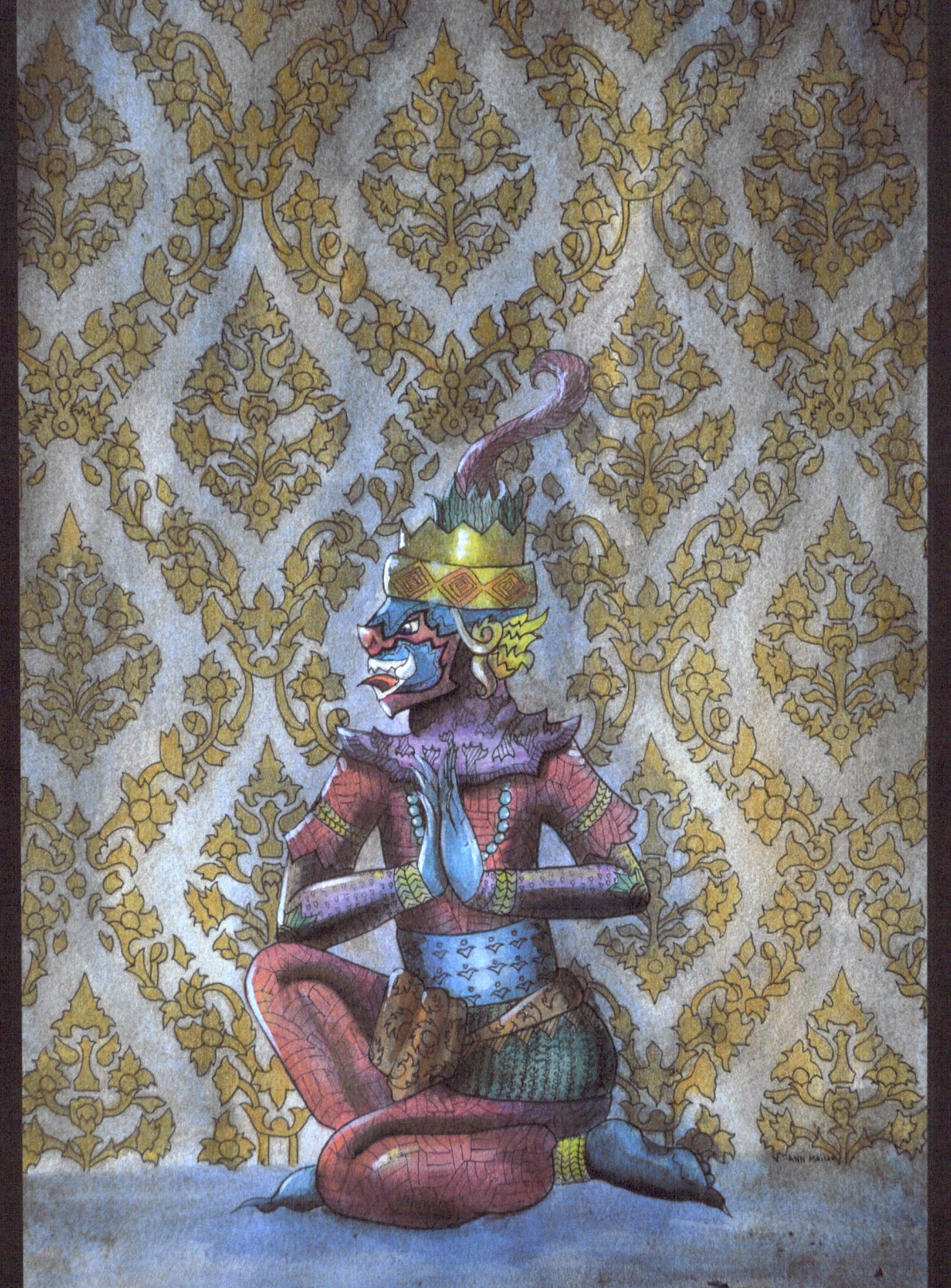

ANDREW

As I reverse engineered a world that would place the moon, not the sun, as the central theological figure I imagined a world where the rapid growth of nocturnal fungi dominated and strange religious rights dictated what and when something was to be done.

This project parralled my personal development as an artist as I saw art and artists in our trip to Reno and did countless developmental sketches. I experimented, as many of my peers did, with different approaches to creating my final pieces. I failed and succeded terrifically multiple times with the mediums and themes I dove into. My major struggle throughout this project centered on knowing when I had said too little versus saying too much. I believe that my pieces reflect this back and forth attitude to my dismay and also to my deep delight.

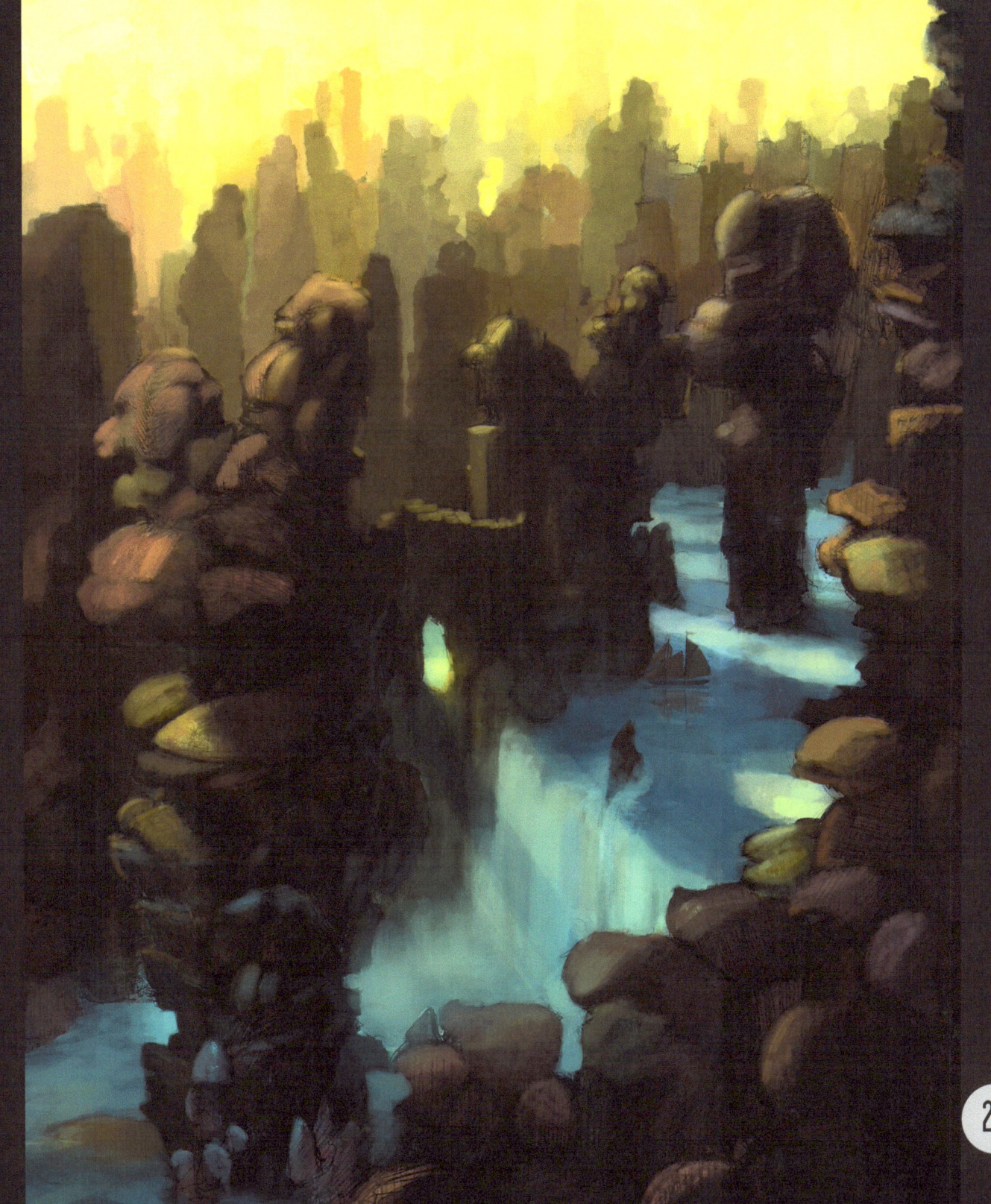

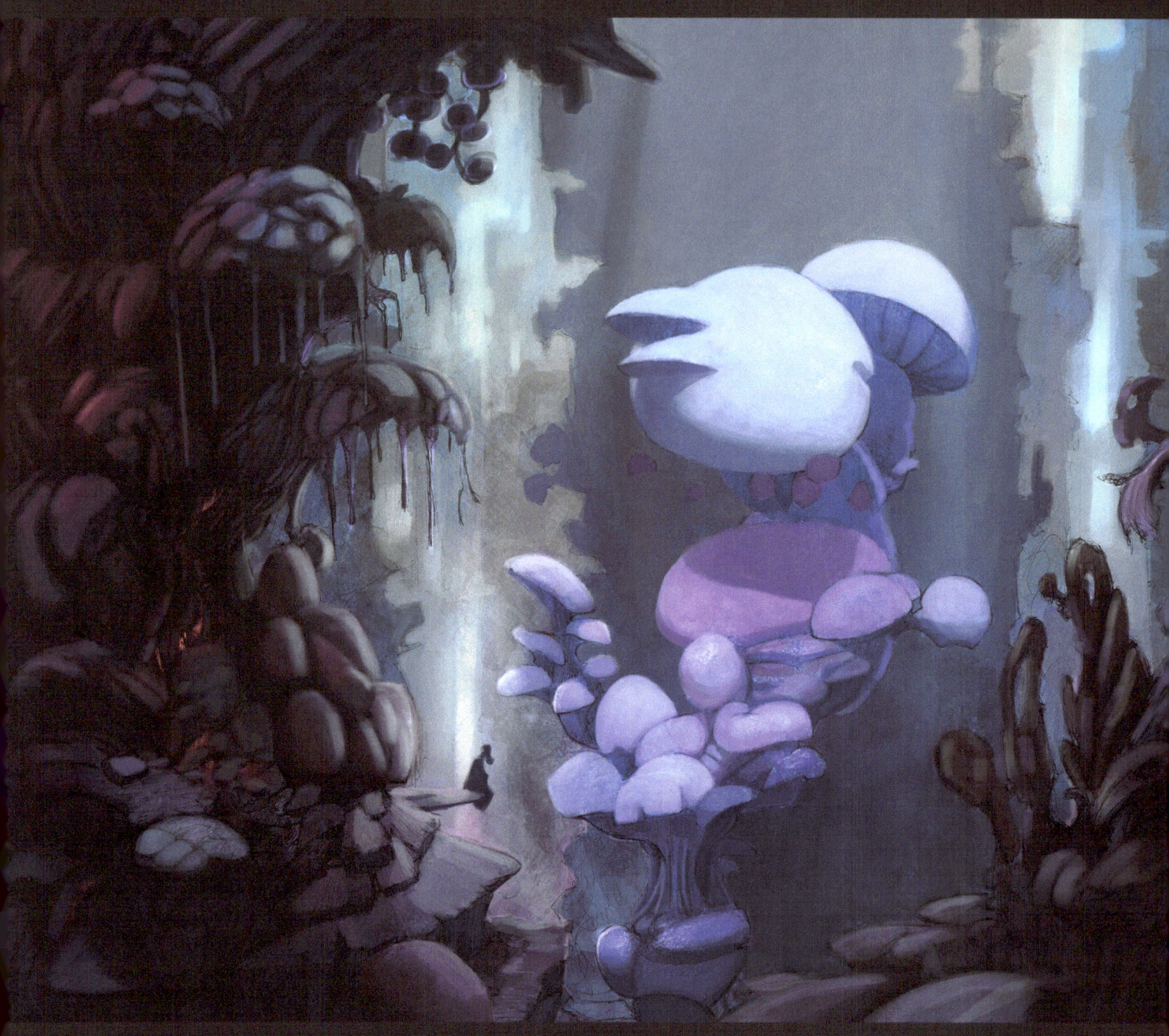

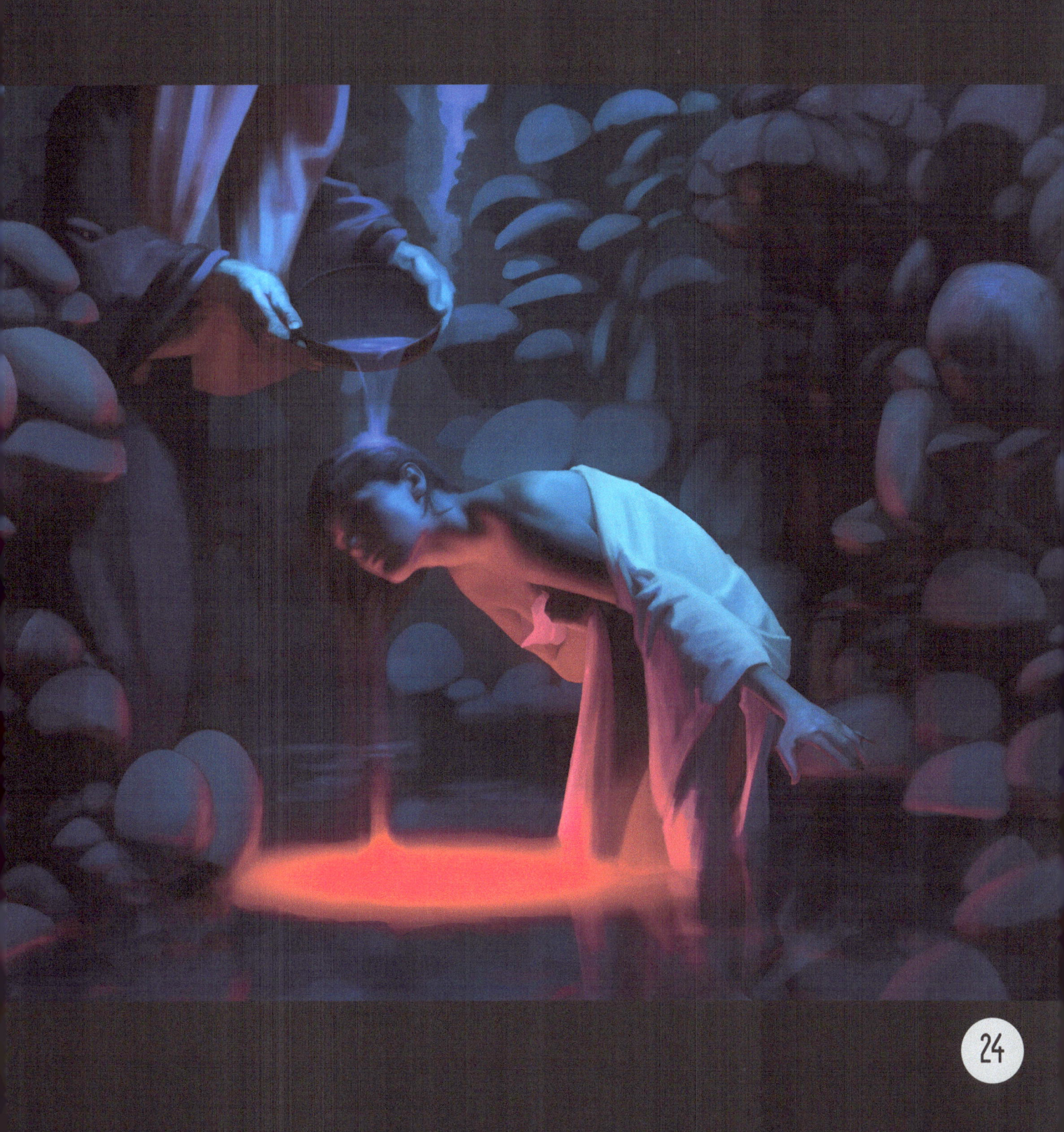

EMILY

I was very inspired by the idea of the moon being terraformed by scientists due to the decline of Earth, preparing the moon for future colonization. Due to the fact terraforming can be a very long and arduous process they cloned their lead scientist in order to maintain the integrity of the project. Three clones are alive at a time and are raised and trained by one another. The three different aspects of the moon goddess, the Maiden, the Mother, and the Crone inspire their roles. The Maiden represents expansion, discovery, youth, and beginnings. Her role is to discover, collect, and study new species of plants and animals that have evolved on their own, without interference from the scientists. The Mother represents power, life, and fulfillment. The Mother's role is to facilitate the evolution and creation of new species for the different needs of the Moon's budding ecosystem. The Crone represents wisdom, death, and endings. The Crone speeds up the process of natural selection, 'editing' out species to increase the efficiency and speed of evolution.

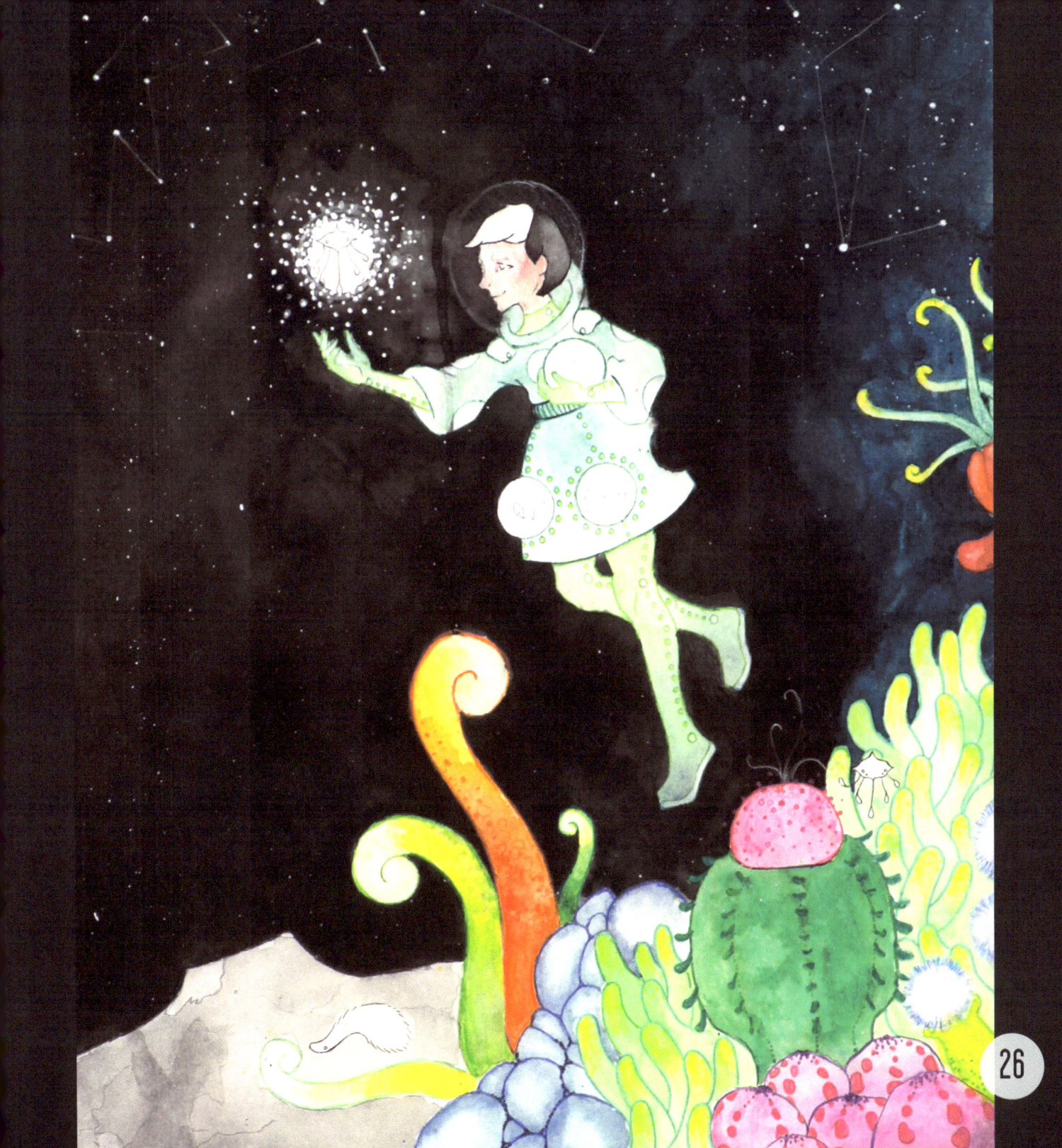

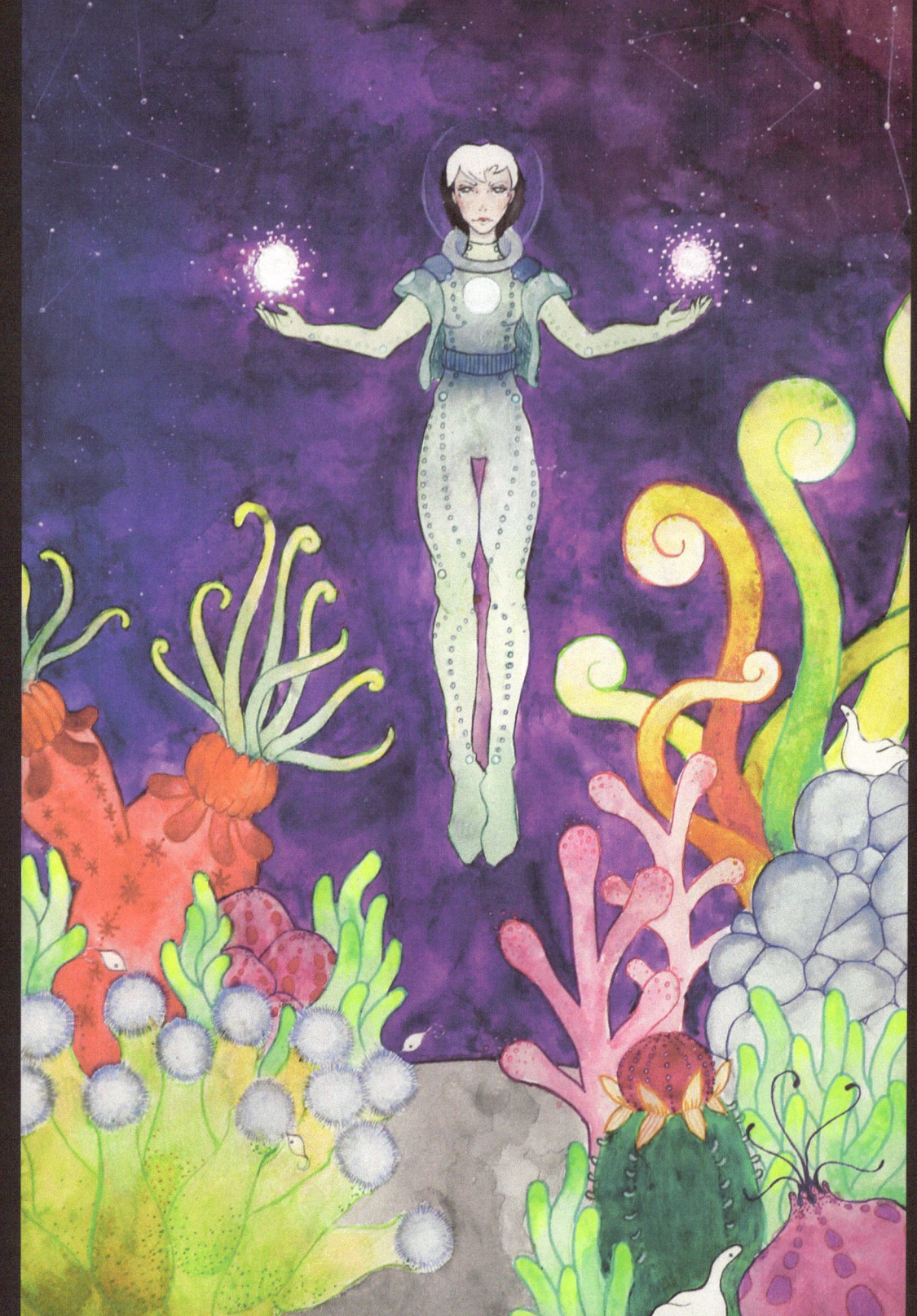

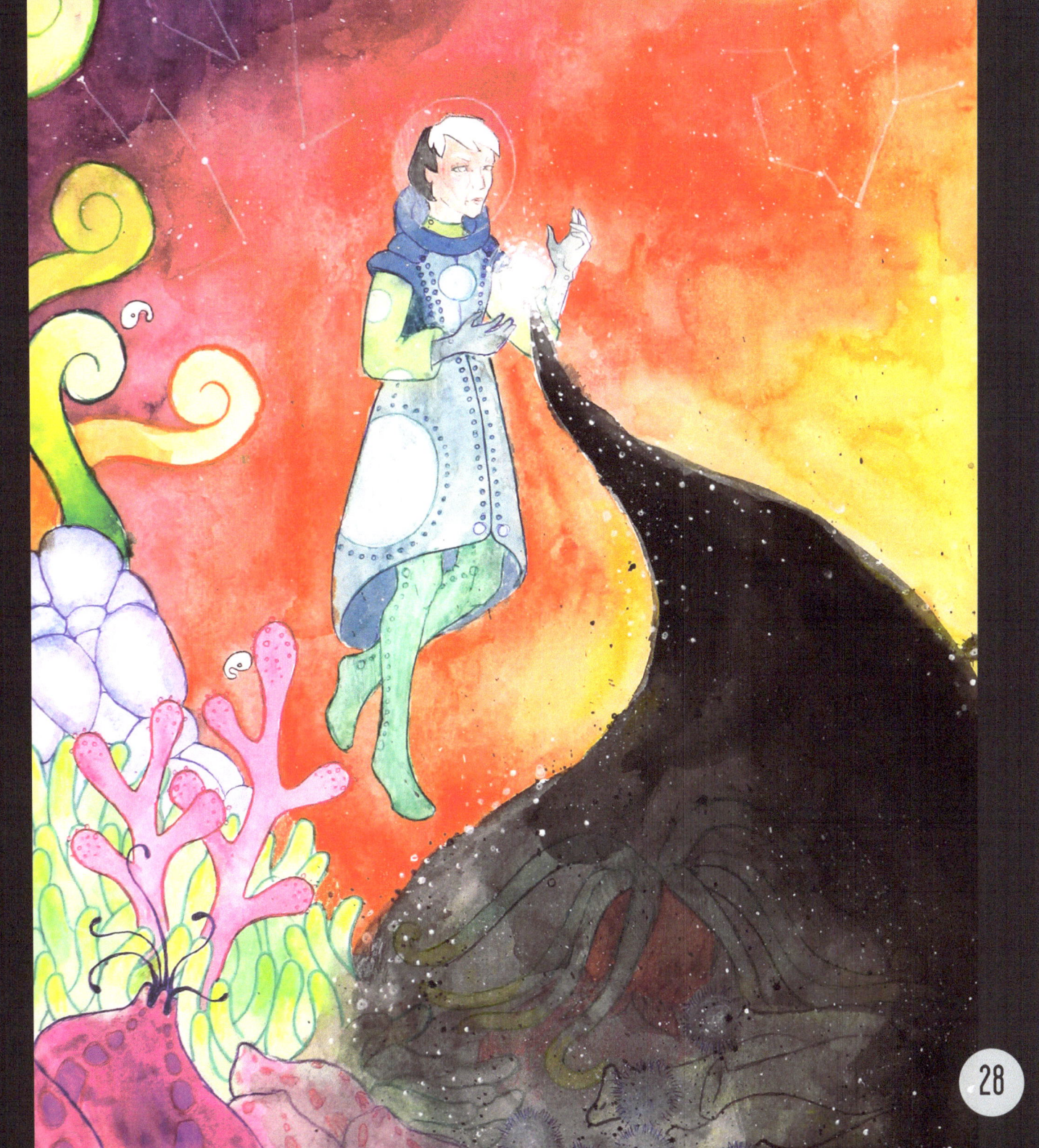

RACHEL

I chose to depict the Moon Goddess as an interpretation of the Triple Goddess, who embodies three aspects of femininity. These aspects—the Maiden, the Matron, and the Crone—serve as the foundation for a larger exploration of various feminine facets, including strength, intelligence, and beauty. The characters in my paintings are archetypes that do not depict individuals in a state of wholeness but rather fractional traits that represent every woman in her unique complexity.

The visual elements reflect a subtle departure from the familiarity of the modern world into fantasy. In addition to a representation of femininity, I also wanted my exploration of the Moon Goddess to serve as a visitation upon the antiquated traditions that have long grown obsolete in the modern world. They are an homage not only to woman-kind, but also to the inherent mysticism intrinsic to the most primal level of humanity.

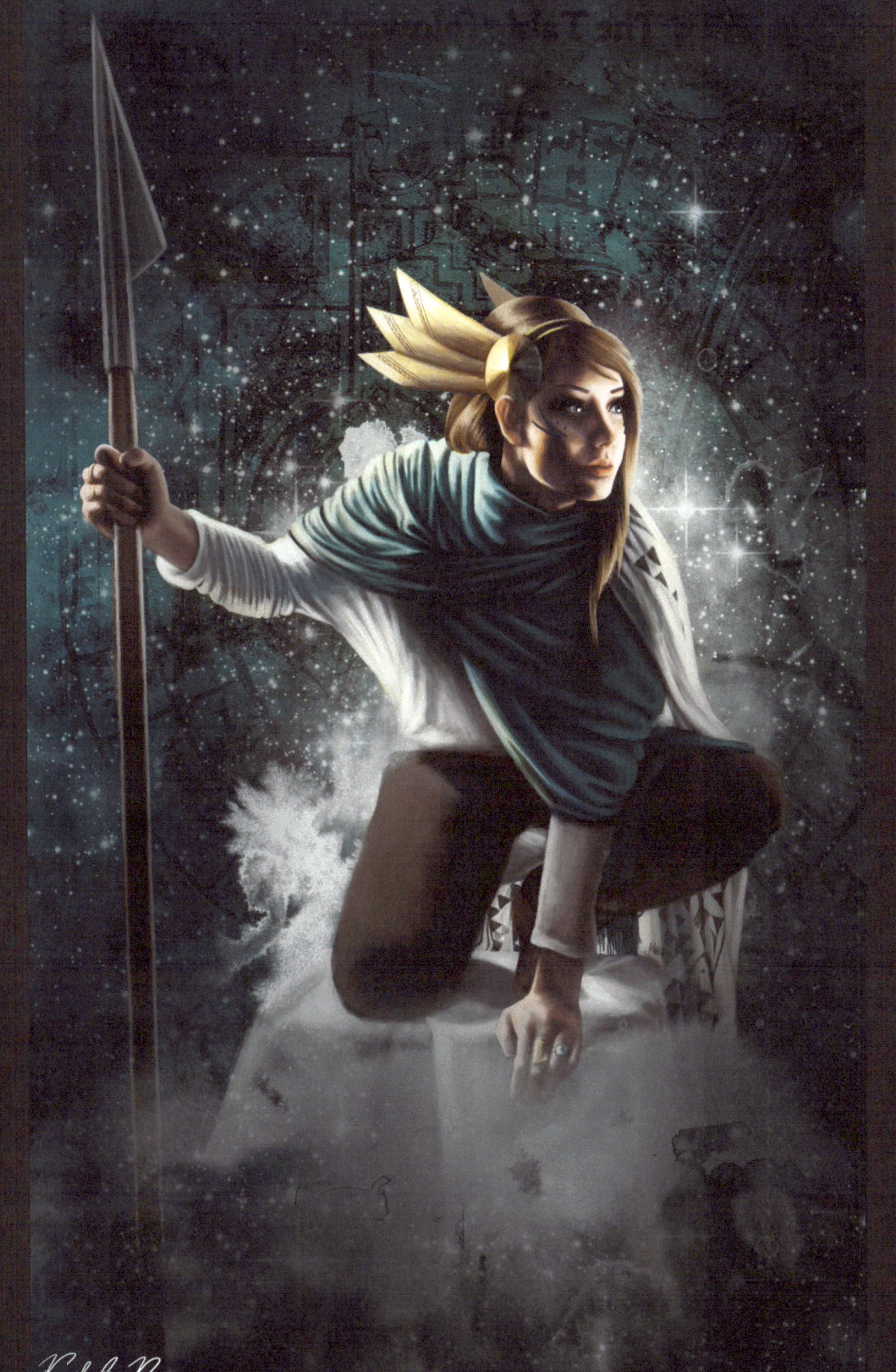

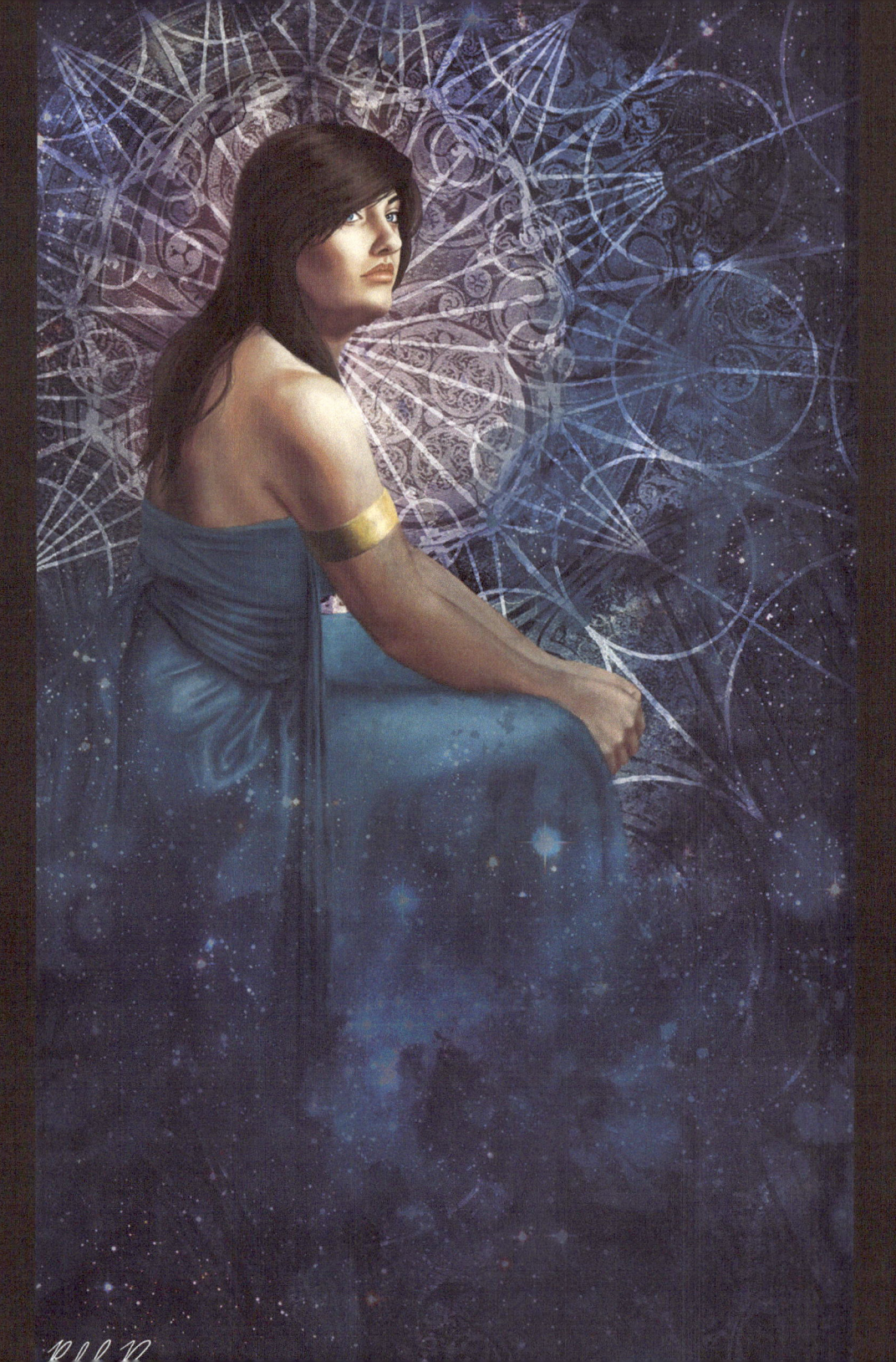

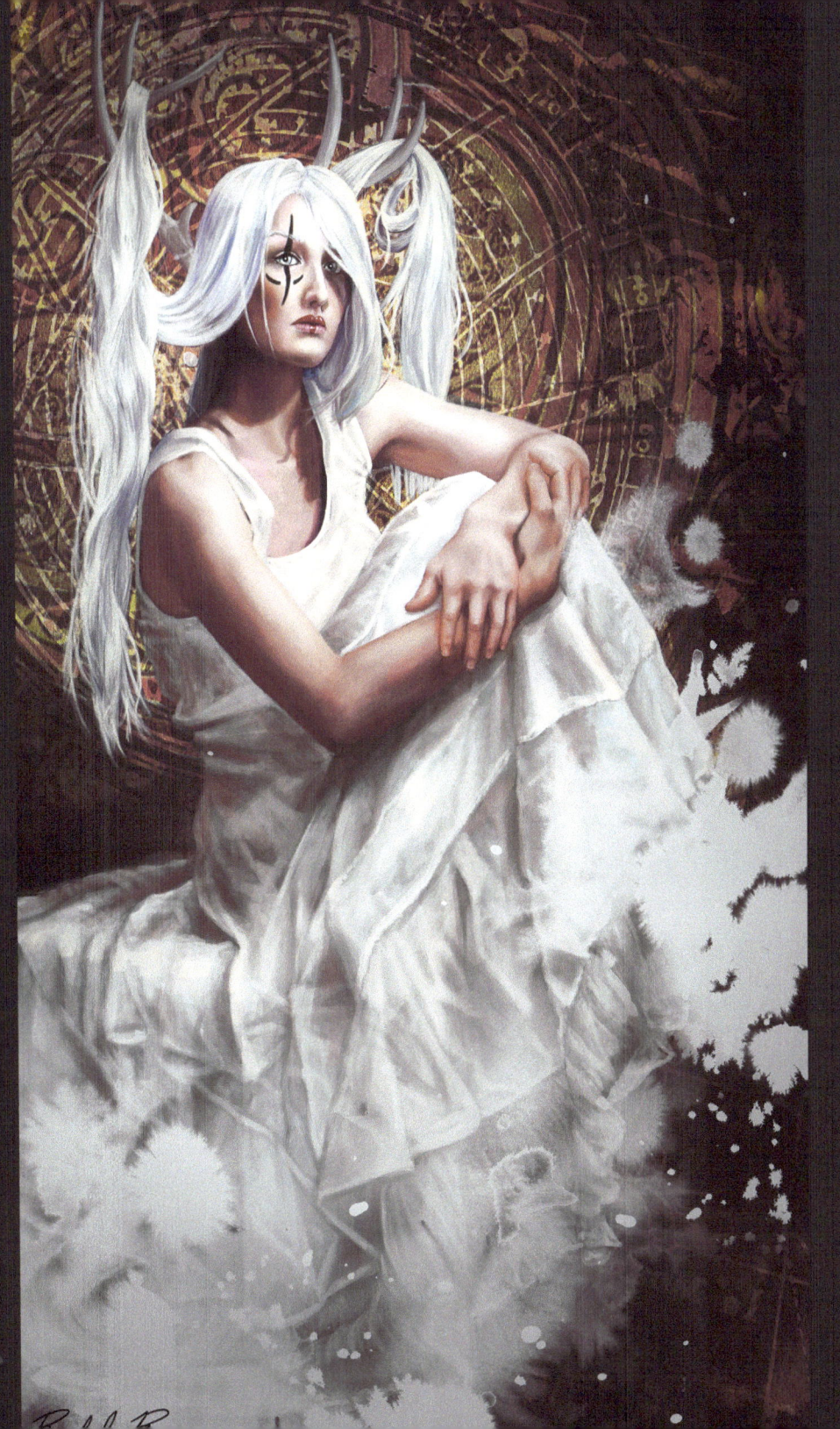

RYLIE

The Moon Goddess project was something that I was really excited to get to work on. I think in stories and so the story for the moon goddess and her sister goddess came quite quickly and developed into a large, but inspiring project. My idea for the project was based off a Chinese Myth about the moon goddess Chang-e, who wasn't so much as a moon goddess herself, but a mortal being that floated up to live on the moon.

From the original myth I developed my own version of the moon goddess, and her sister goddess, and through a long process of thumbnails and development sketches, I produced these first three pieces depicting the story of the goddesses and their journey toward finding themselves. I have more plans for this series and am currently working on the last 3 pieces to be included in a show toward the end of the spring semester.

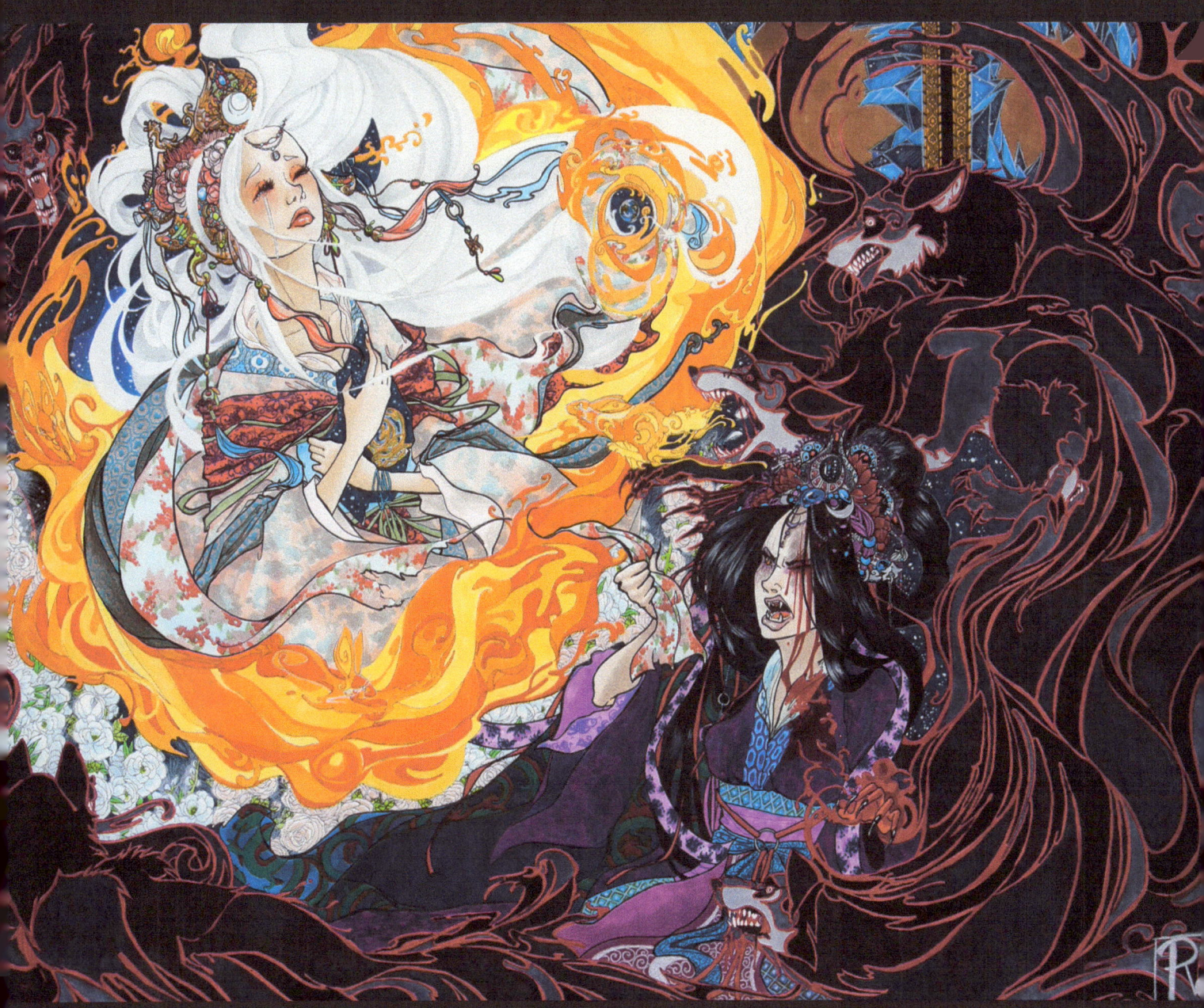

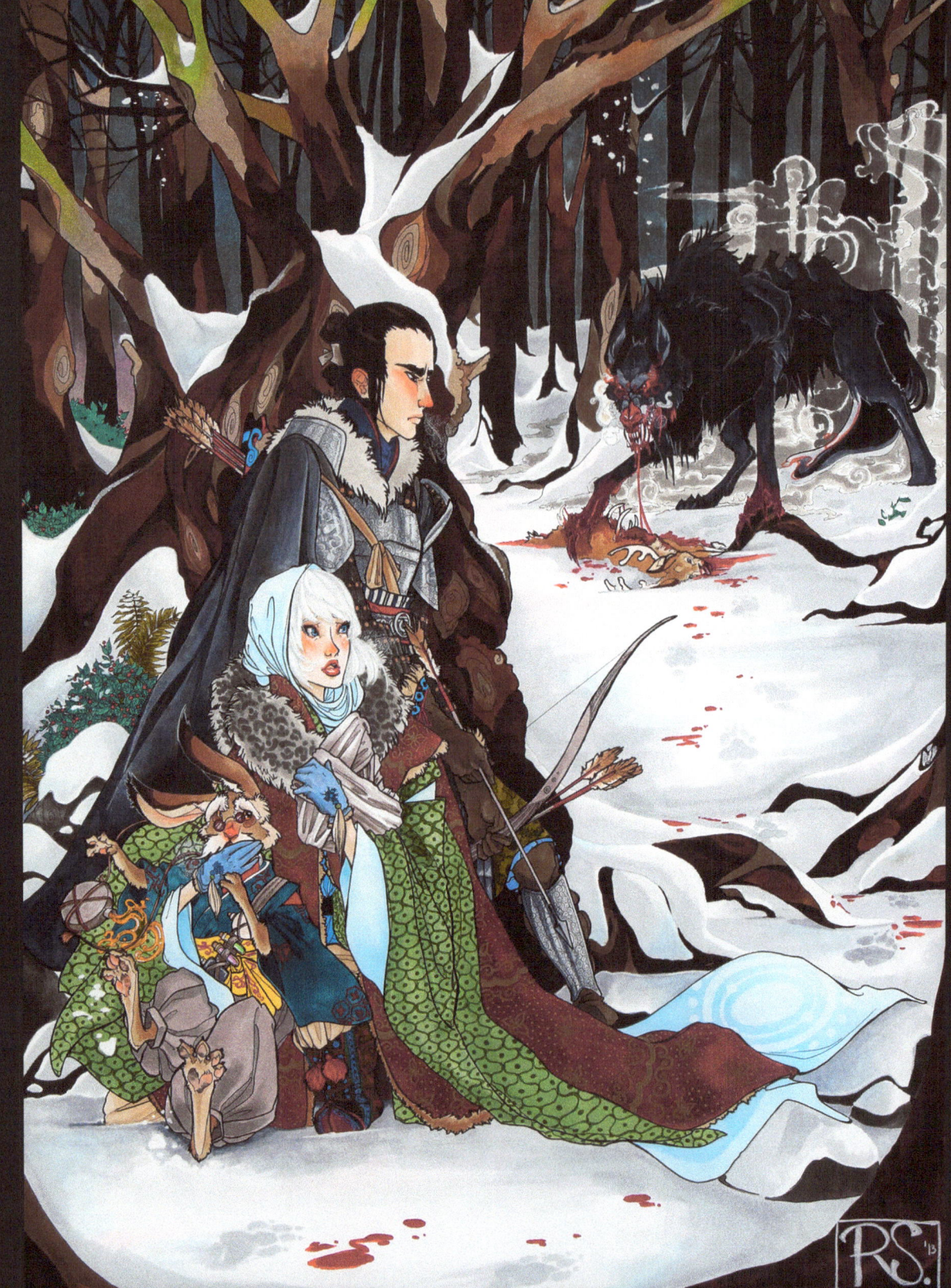

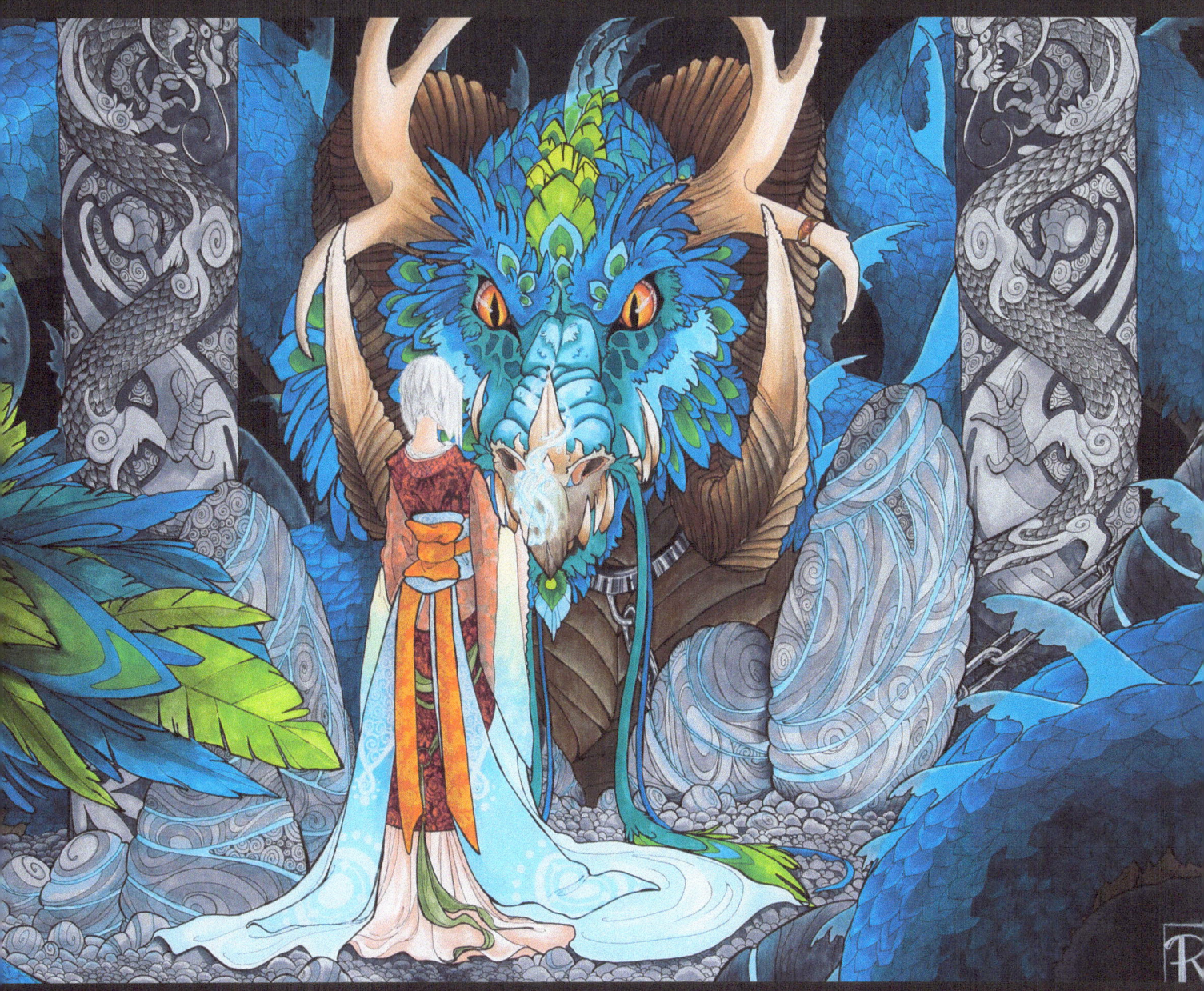

JOHN

This project has been a very fun and very challenging art experience for me. We were literally given complete creative control over everything we did, start to finish. I decided to use all of this freedom to challenge myself to try new things whether they worked out or not.

I started this project by making a lot of sketches. Everything was very random and stream-of-conscious kind of stuff. What I ended up with was two very unrelated things: worms and pumpkins. I settled on these because they were the first things that I drew that I felt really set my stuff apart from everyone else and because they are fun to draw. My next task was to figure out how those applied to a Moon Goddess. Truthfully, I'm not sure if I ever did find out the connection.

I took three different approaches for my three separate pieces. The variety of media was great for figuring out what my strengths and weaknesses are in art. I used a combination of digital, ink, acrylic, and collage all in an attempt to find what truly worked best.

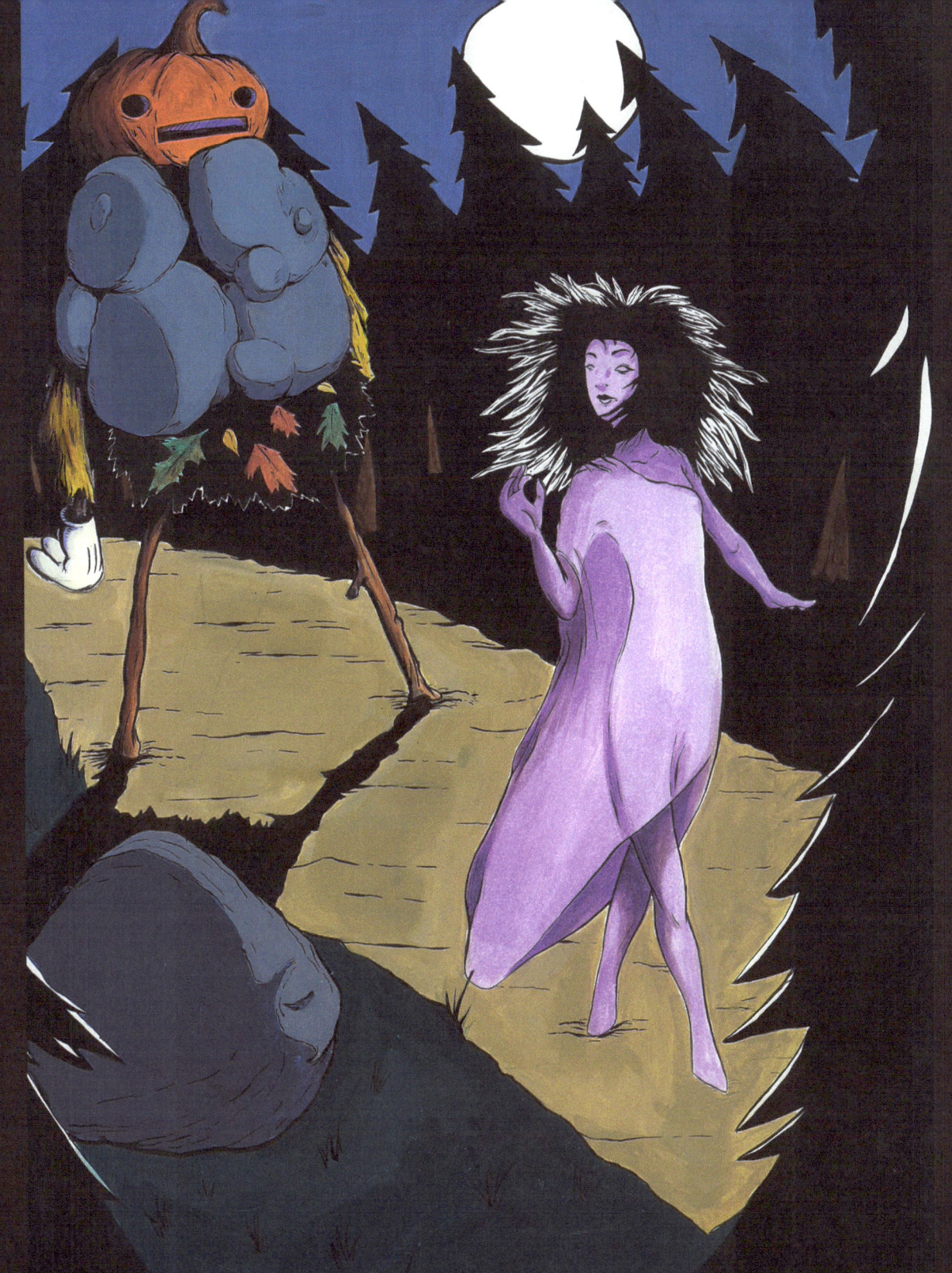

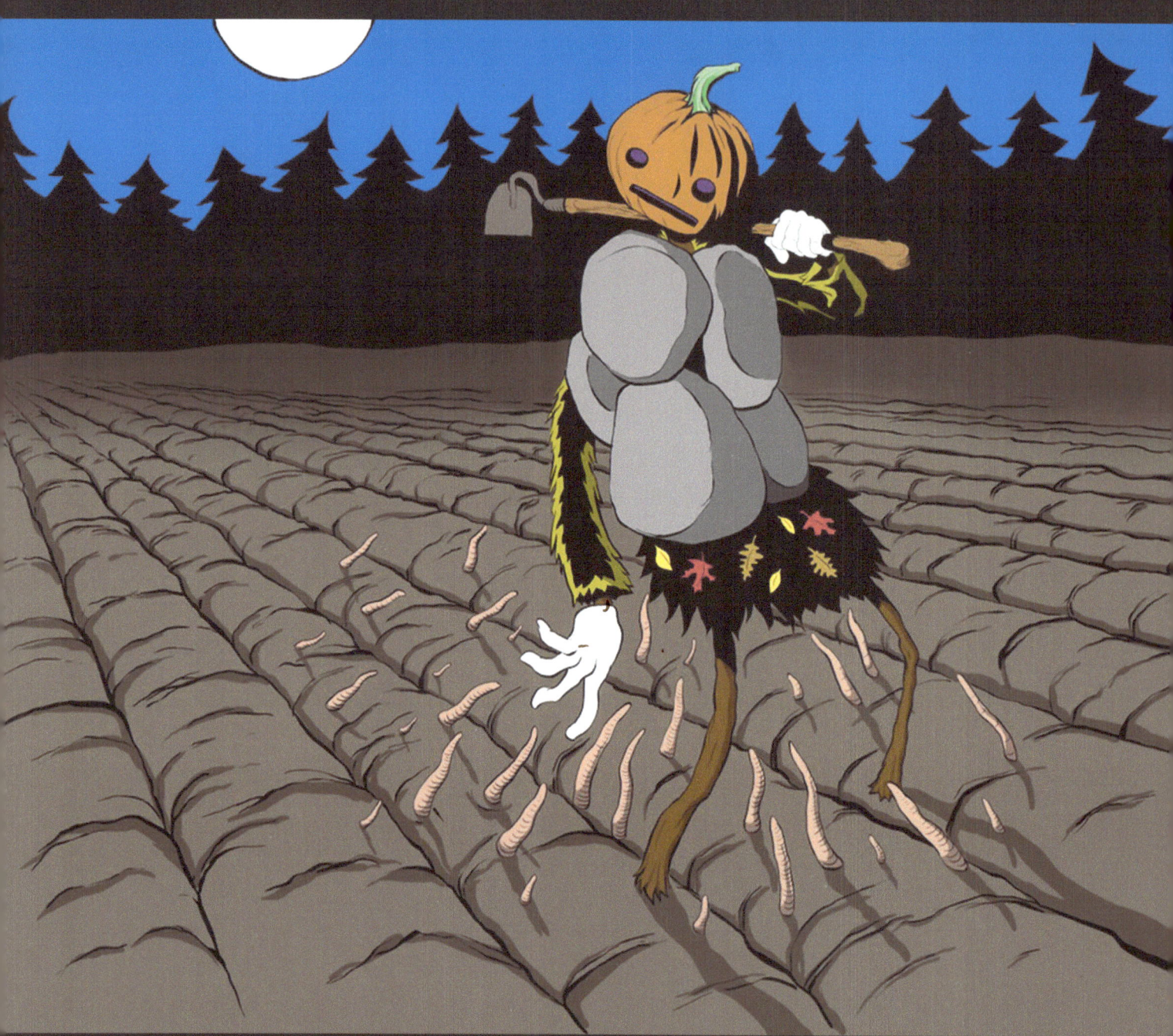

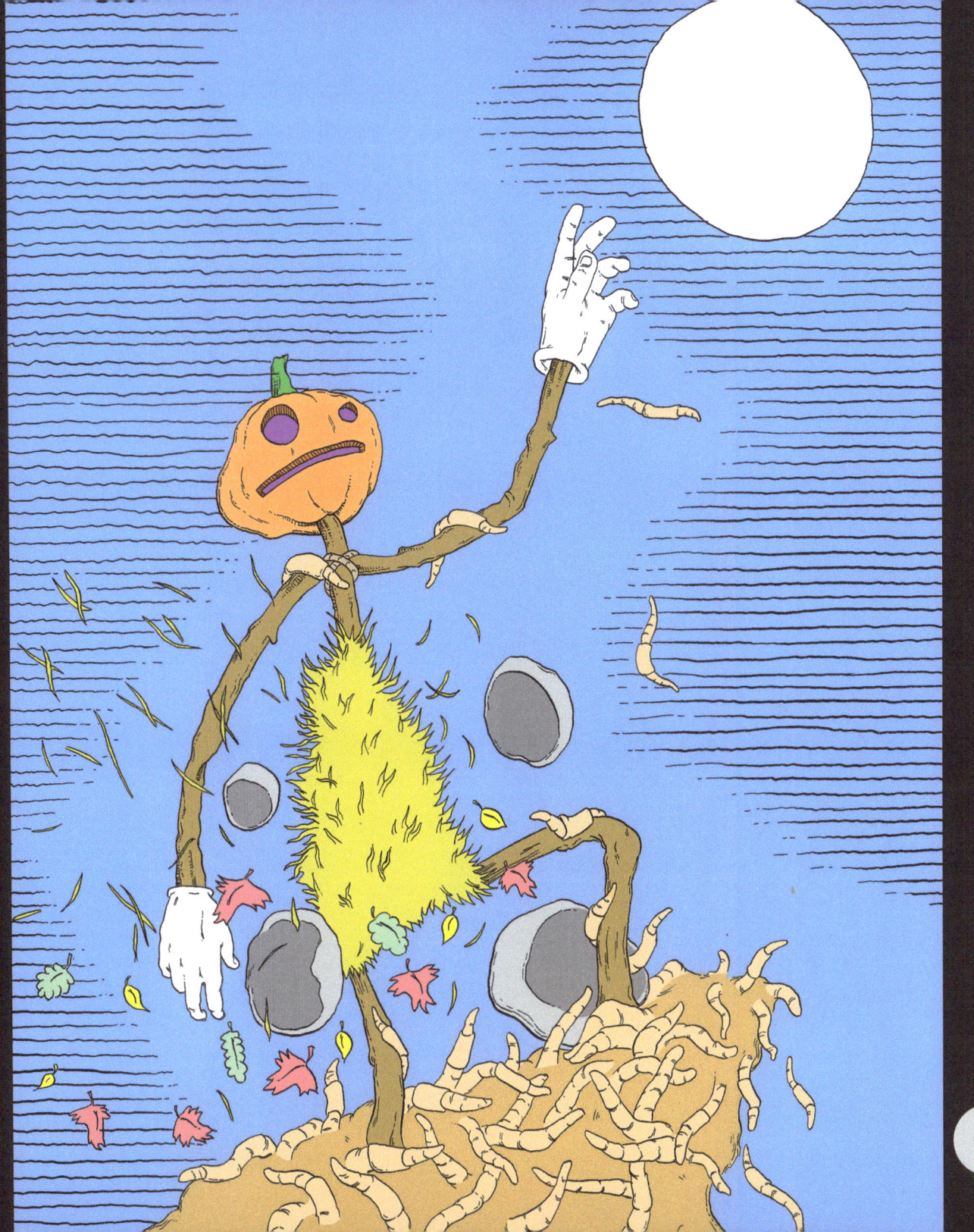

END

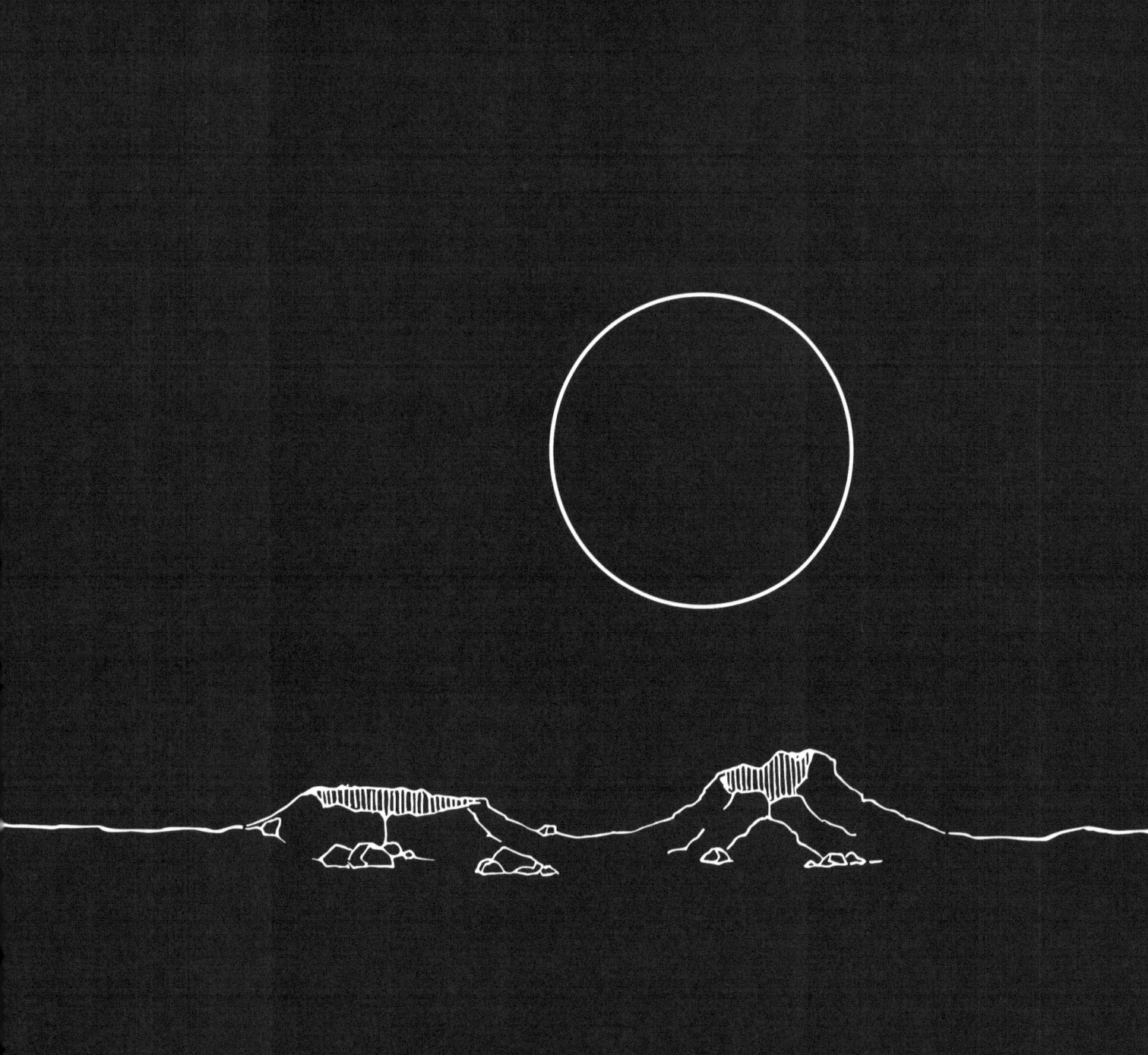

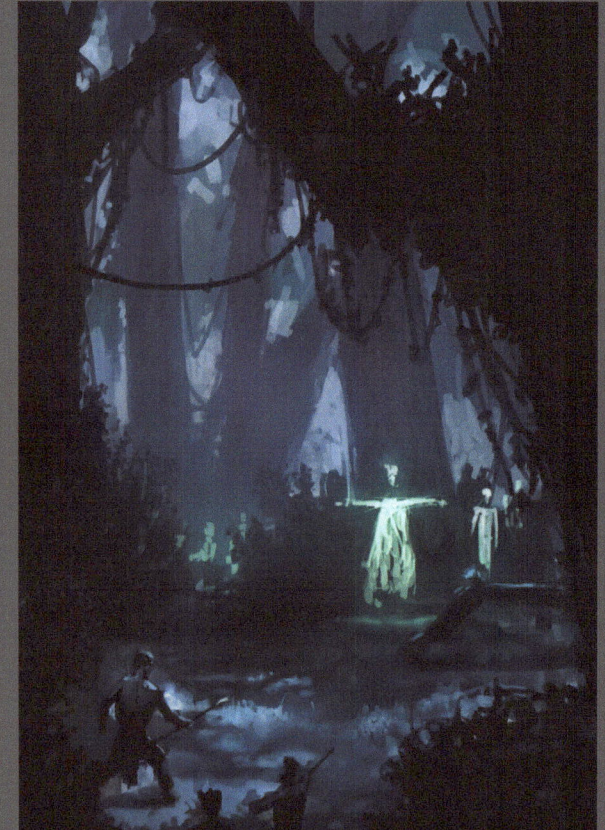

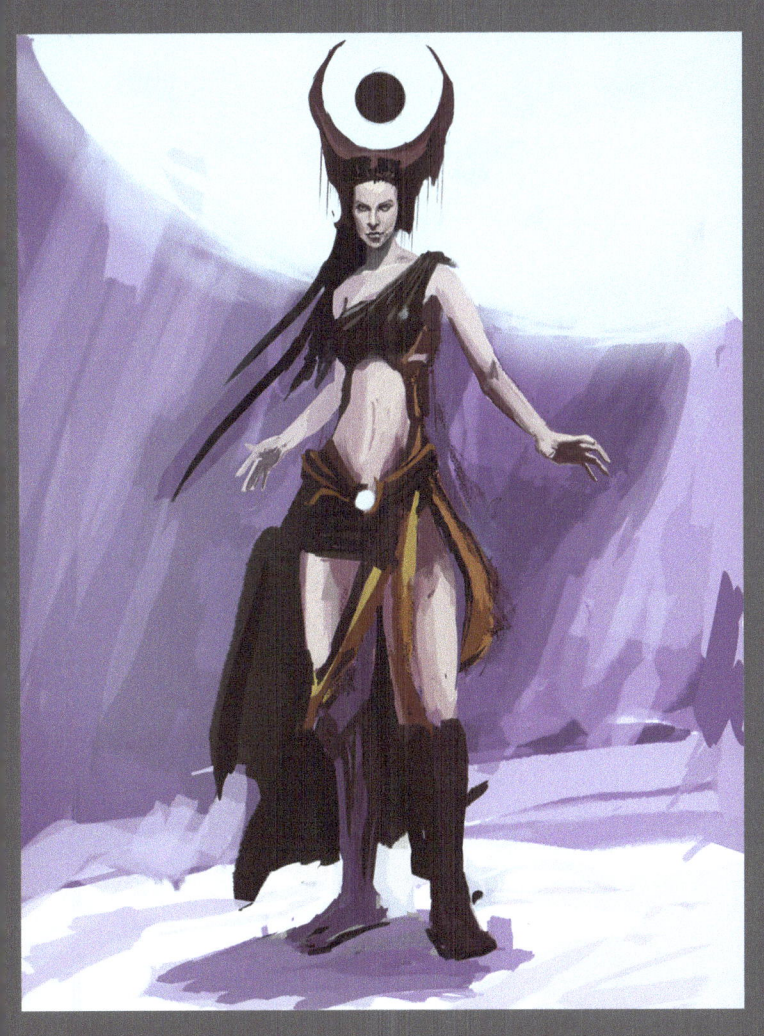
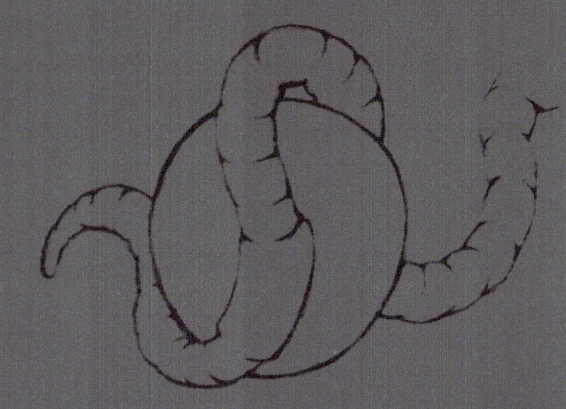
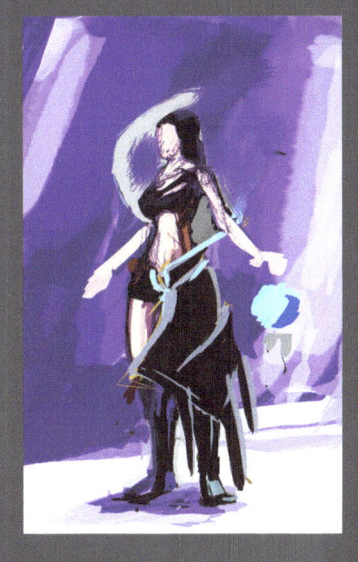
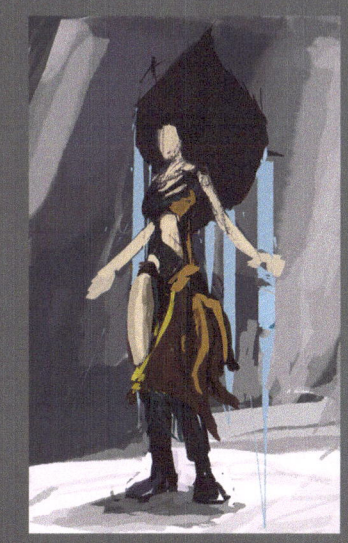
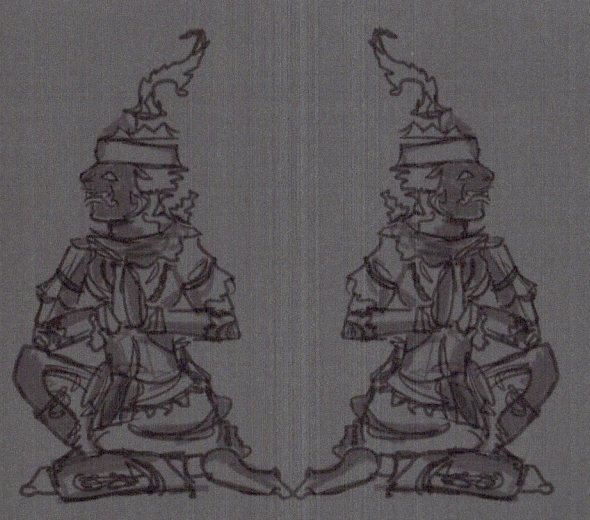
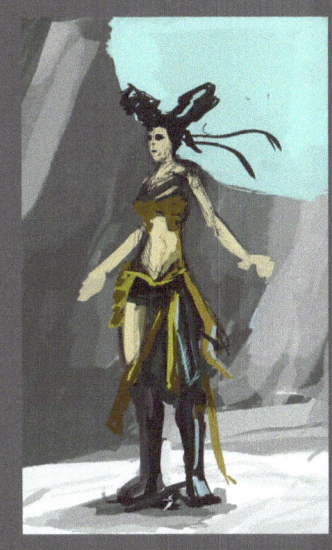
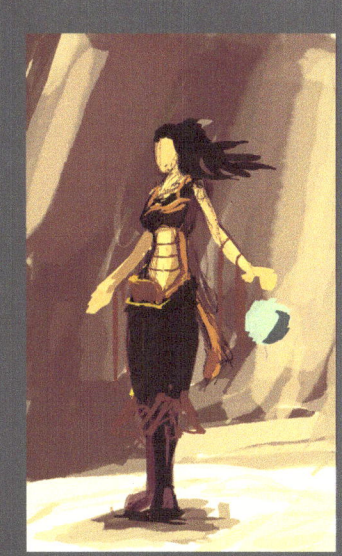

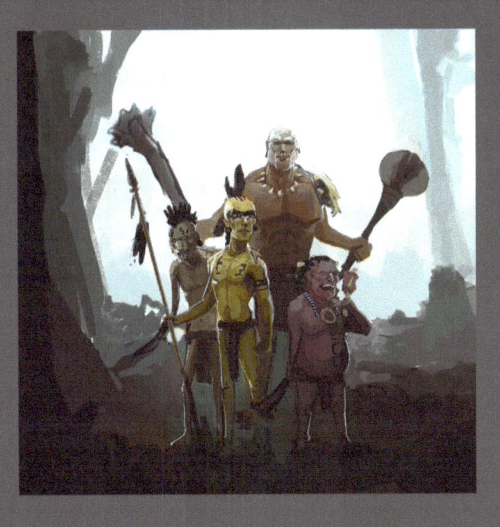
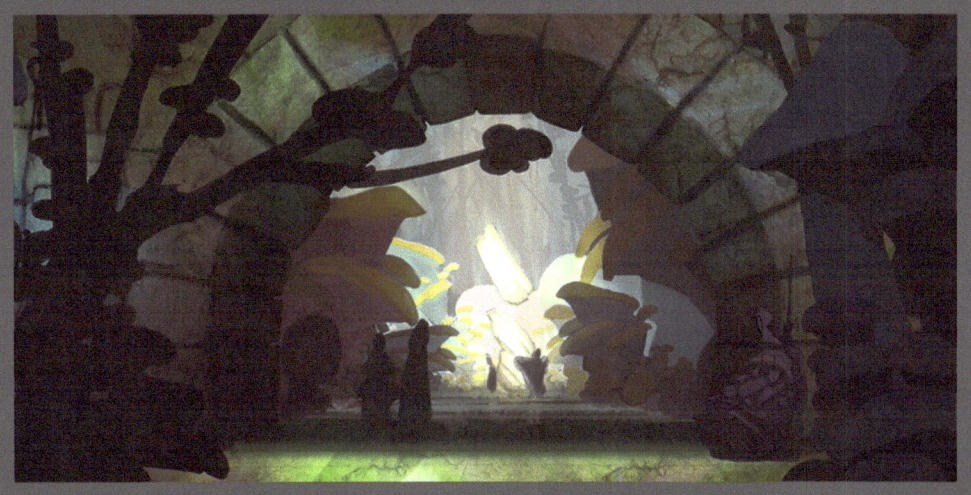

SPECIAL THANKS

Lisa L. Cyr

Q. Cassetti

Ron Spears

Val Paul Taylor

Anna Preston

Turkey Stremmel

Richard Hescox

Jerry Stinson

Bally Technologies

IGT-International Gaming Tech.

VGT-Video Gaming Tech.

St. Mary's Art Center

SUU Art Department

www.ingramcontent.com/pod-product-compliance
Lightning Source LLC
Chambersburg PA
CBHW050858180526
45159CB00007B/2722